O! None, unless this miracle might,
That in BLACK INK MY LOVE MAY STILL SHINE BRIGHT.
— WILLIAM SHAKESPEARE

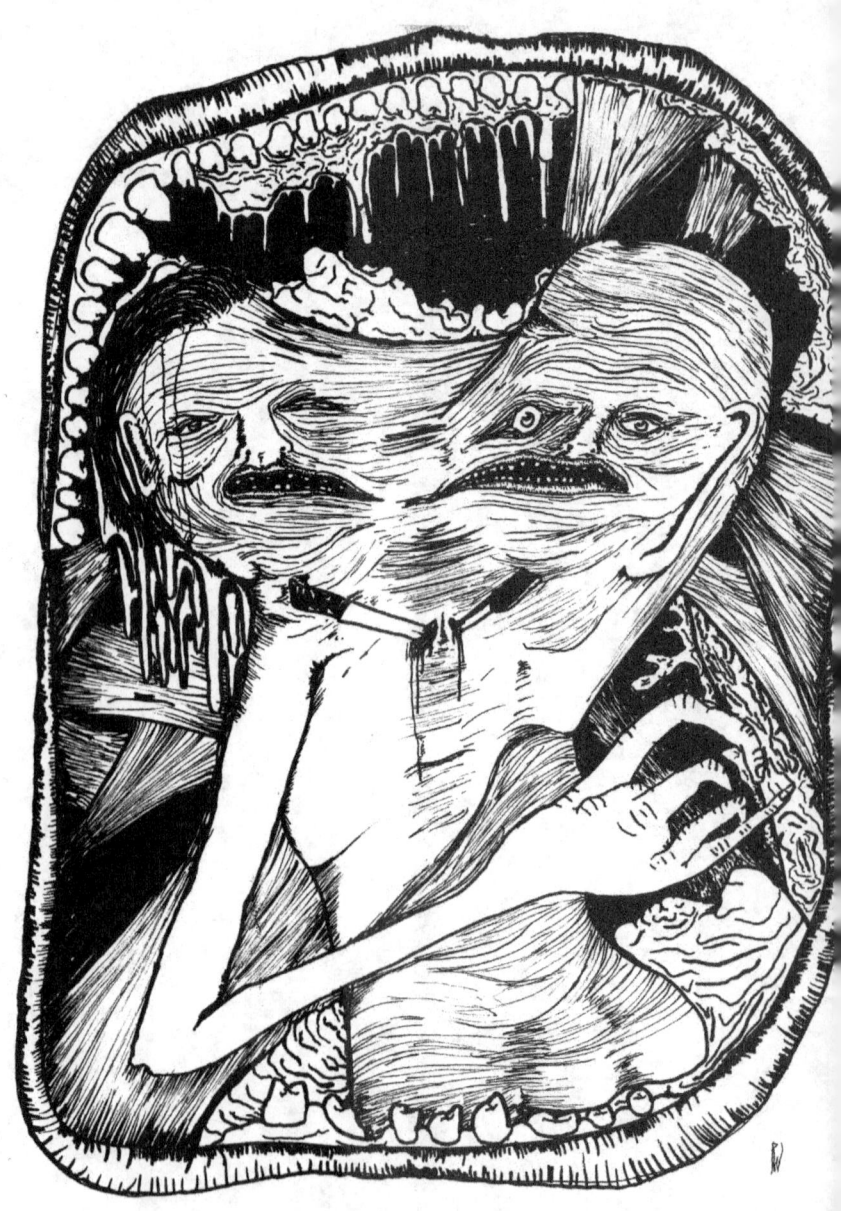

The Joining

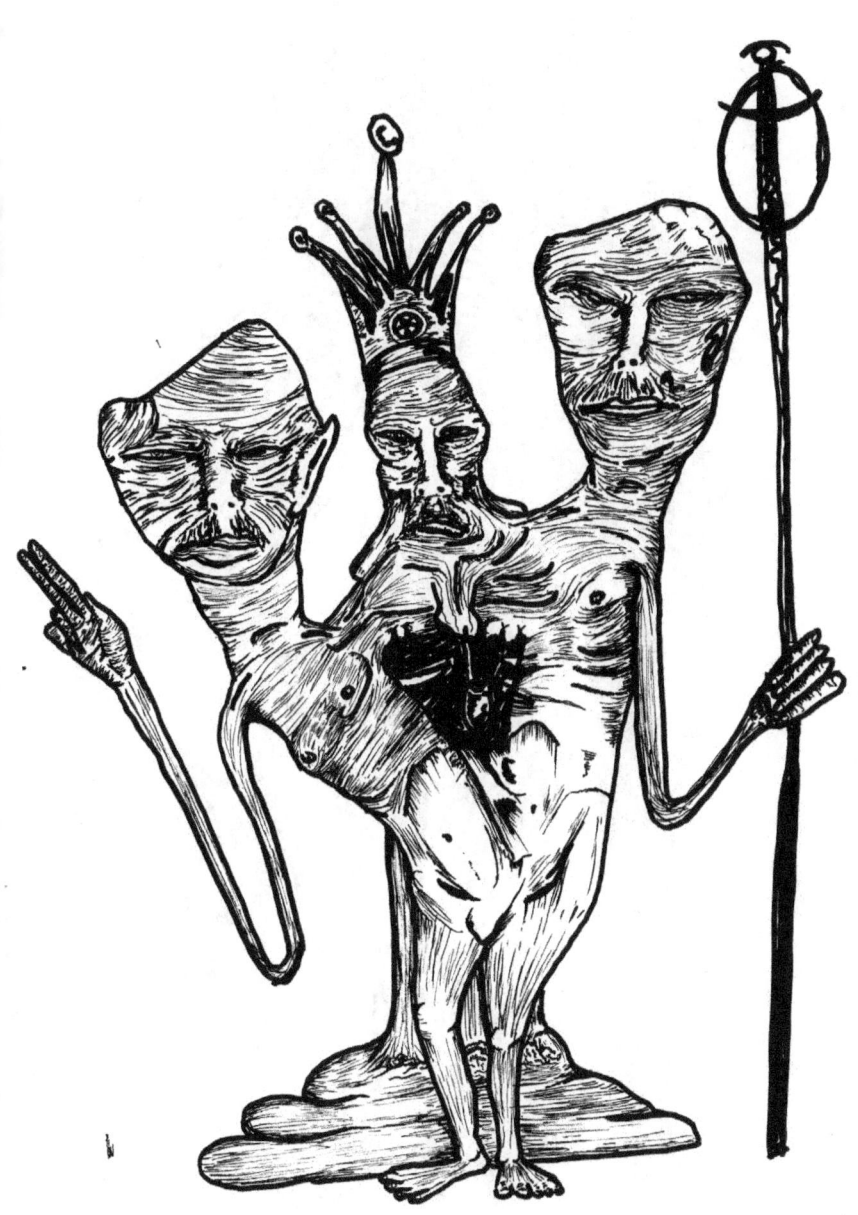

The Unholy King

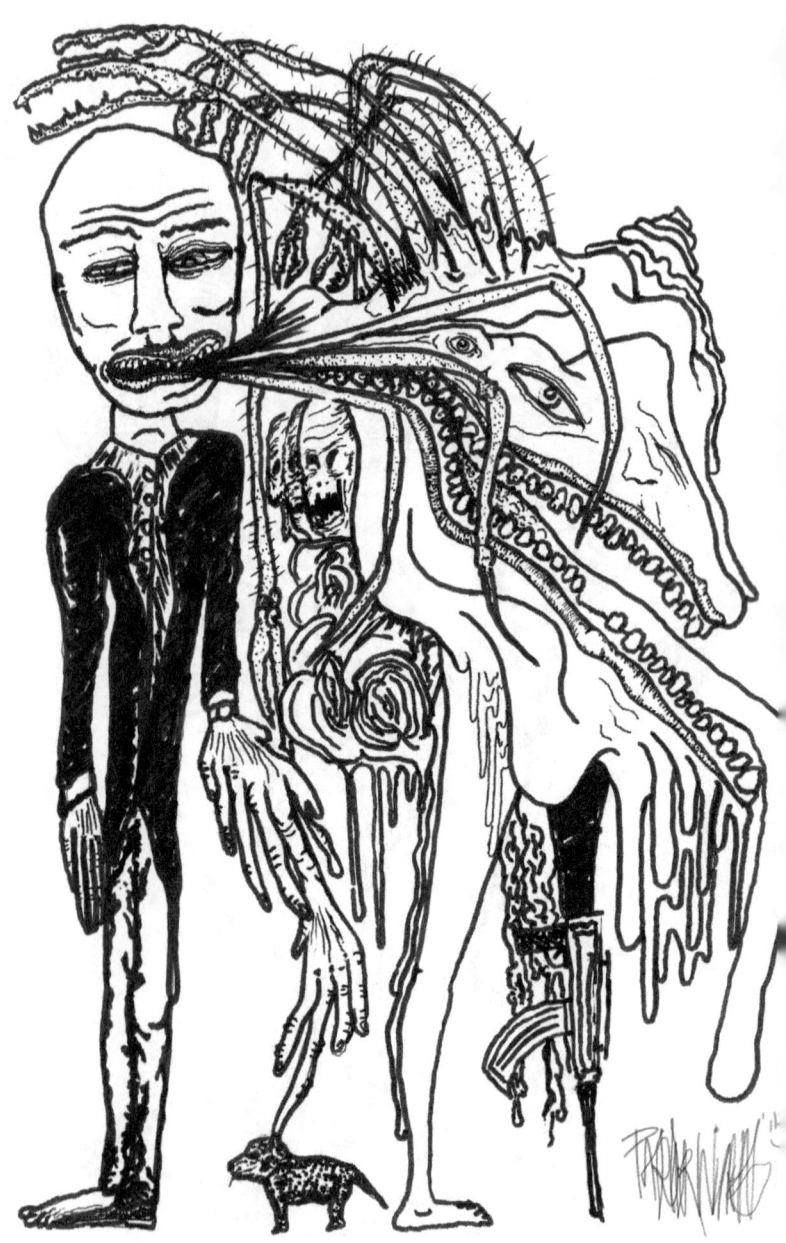

The Creep

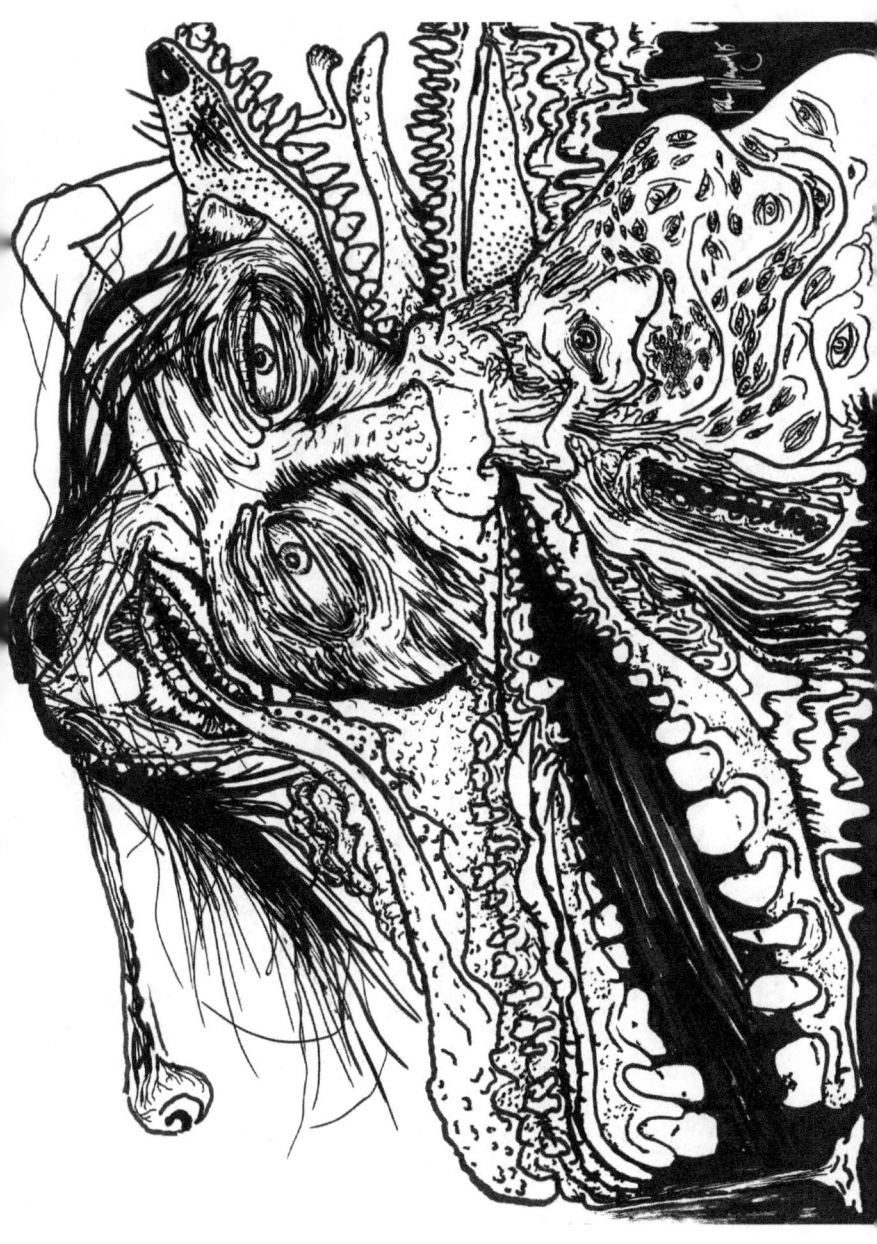

The Word

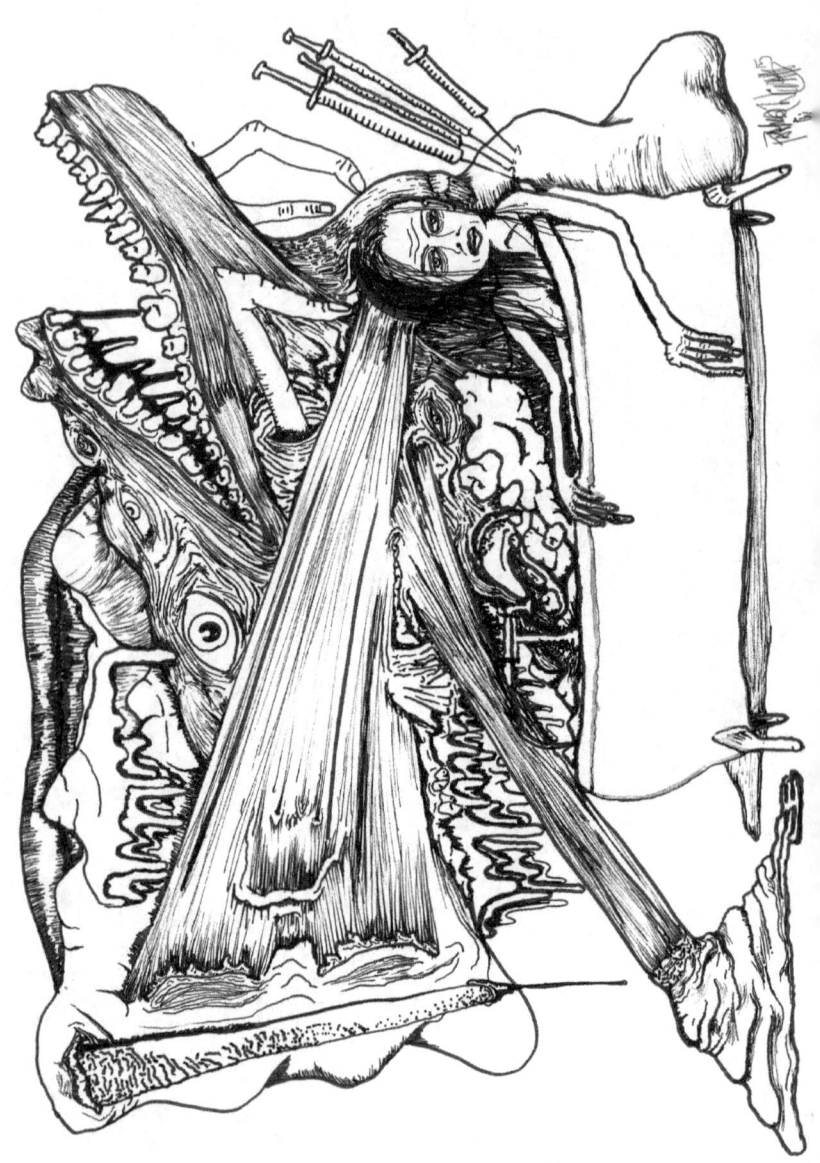

The Bath

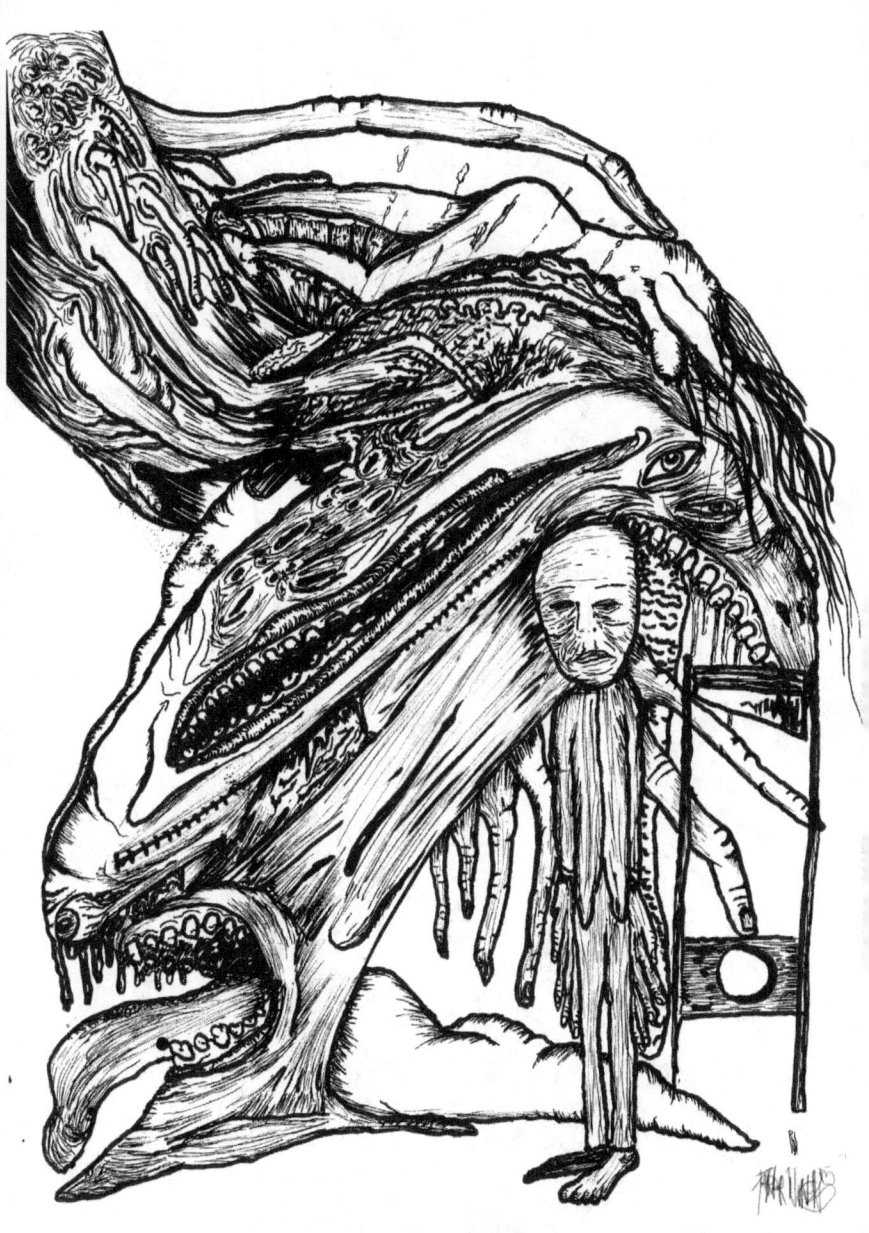

The Guillotine

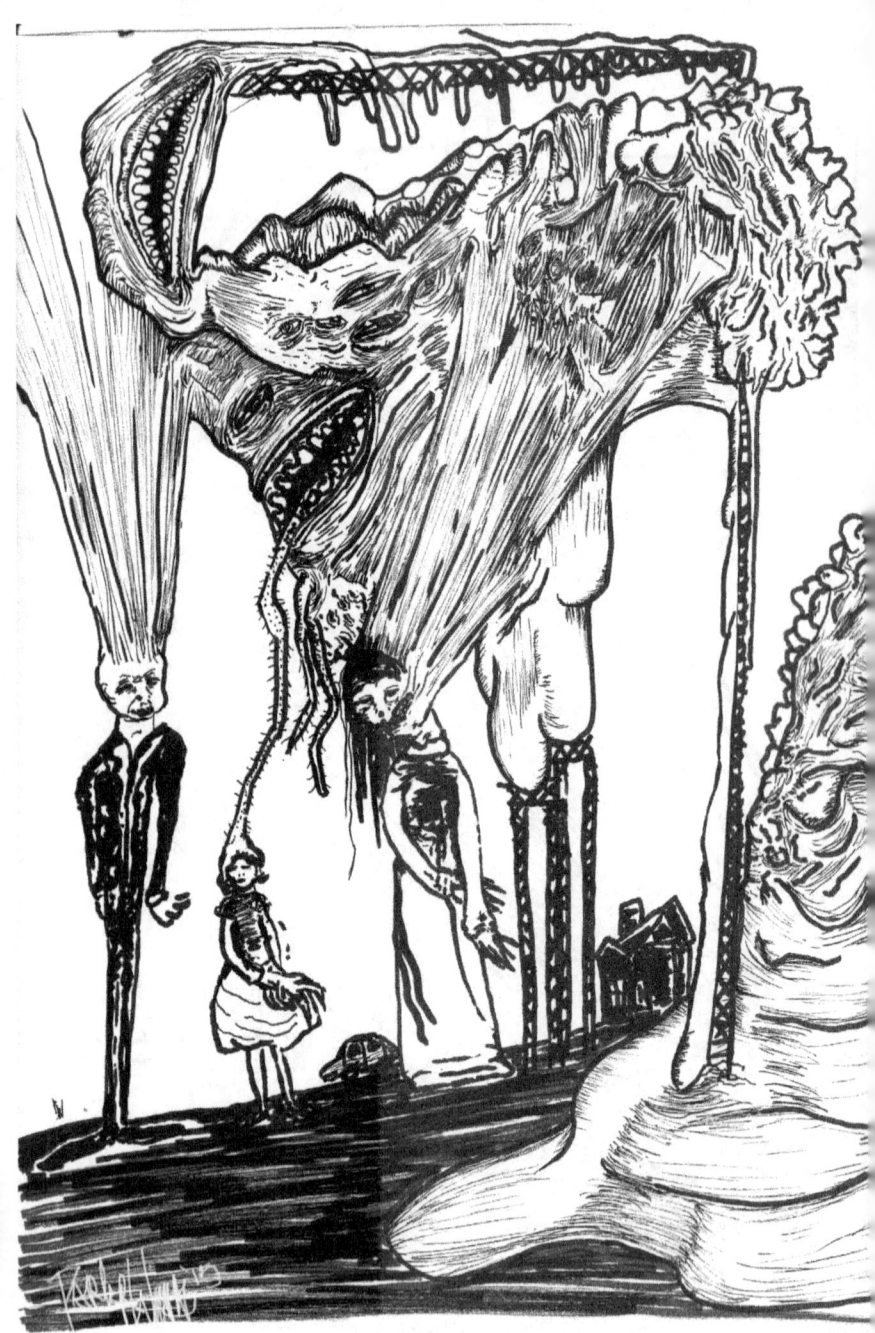

The Family

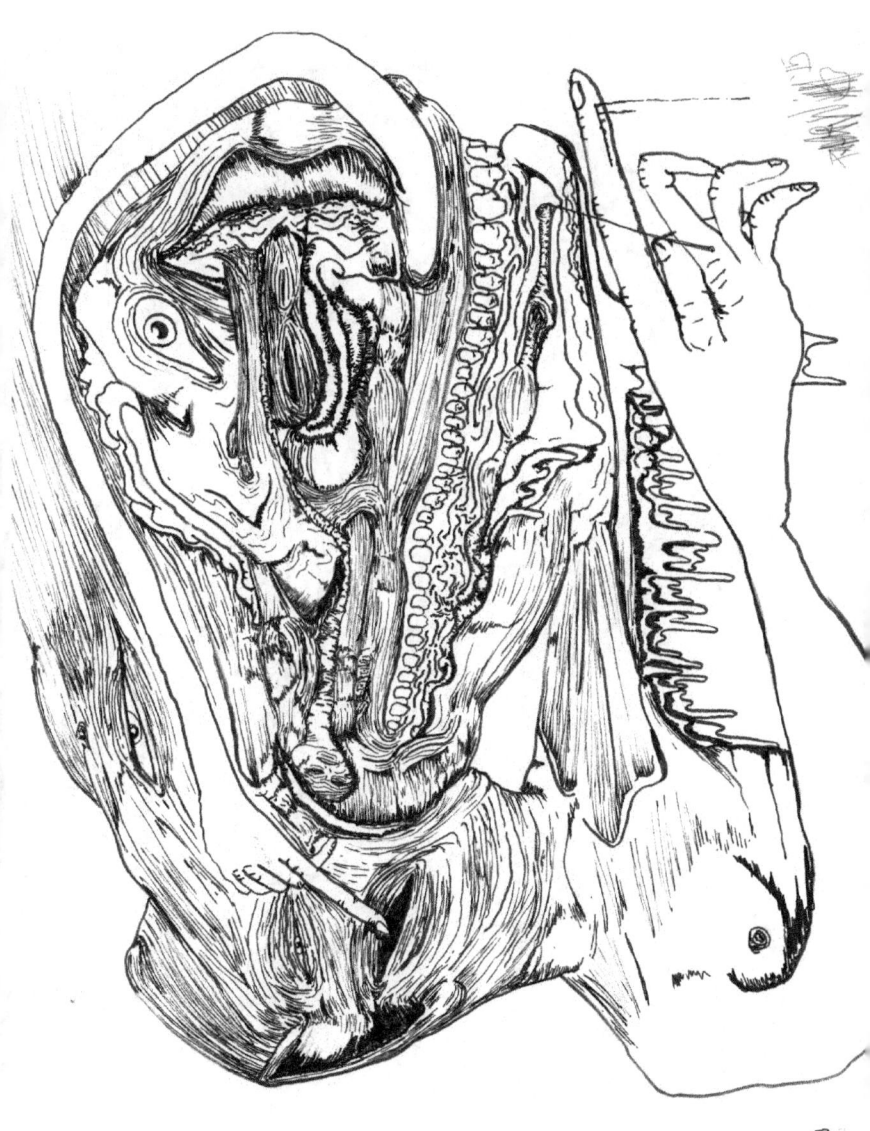

The Itch (Pointing Fingers)

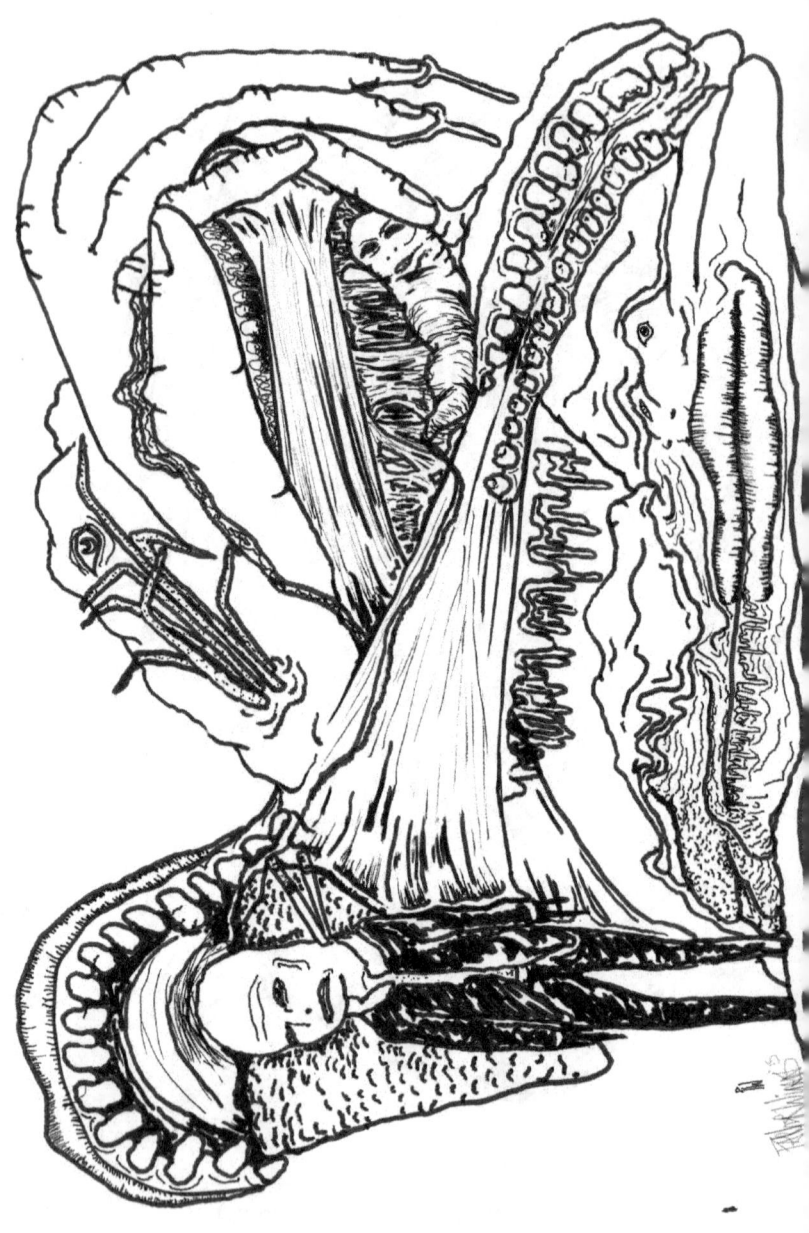

The Knives

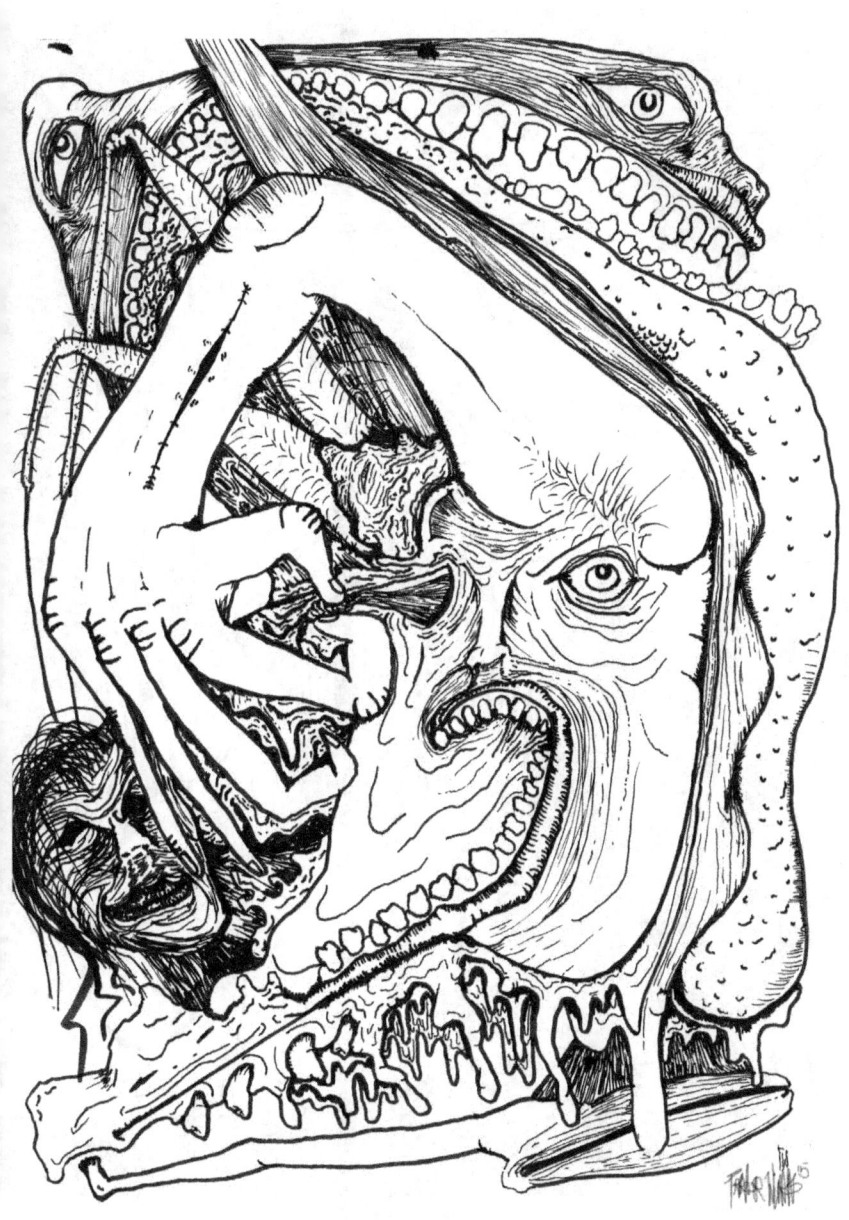

The Trick

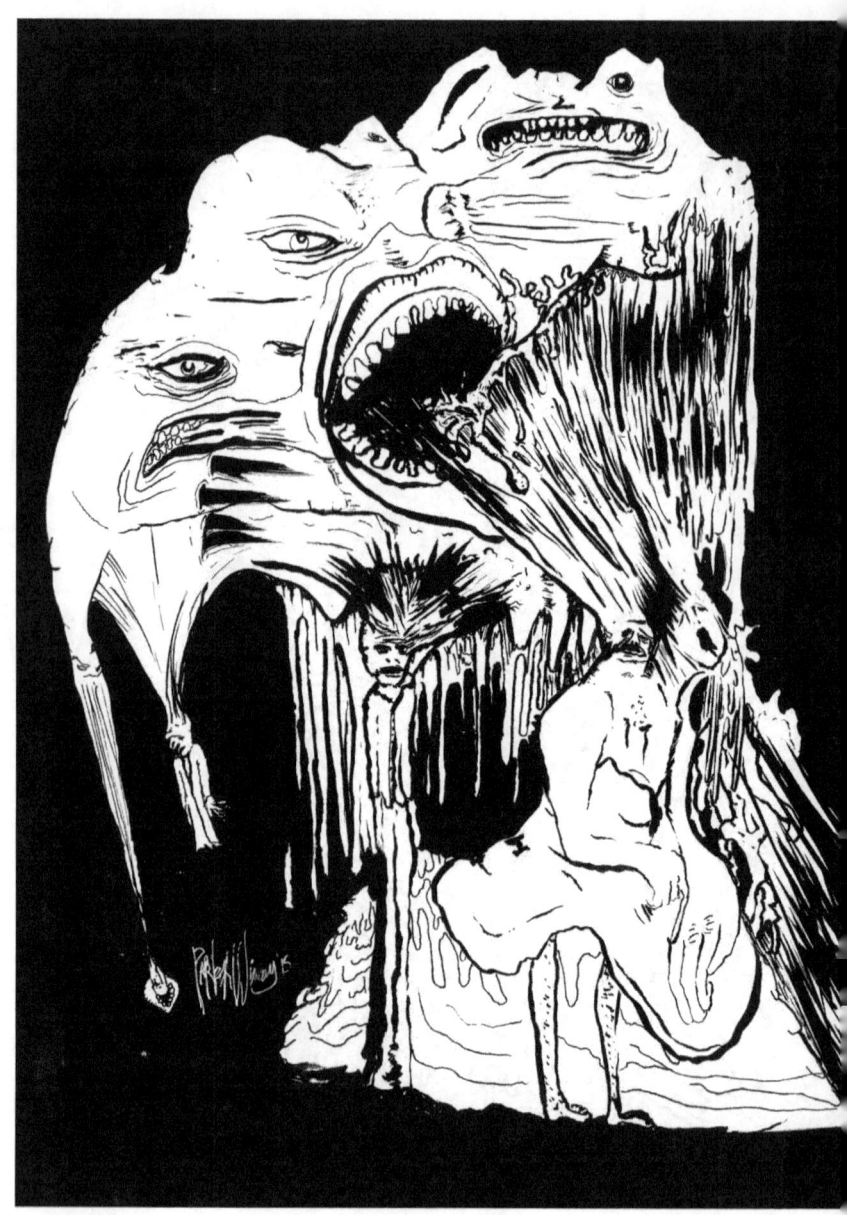

The Rash

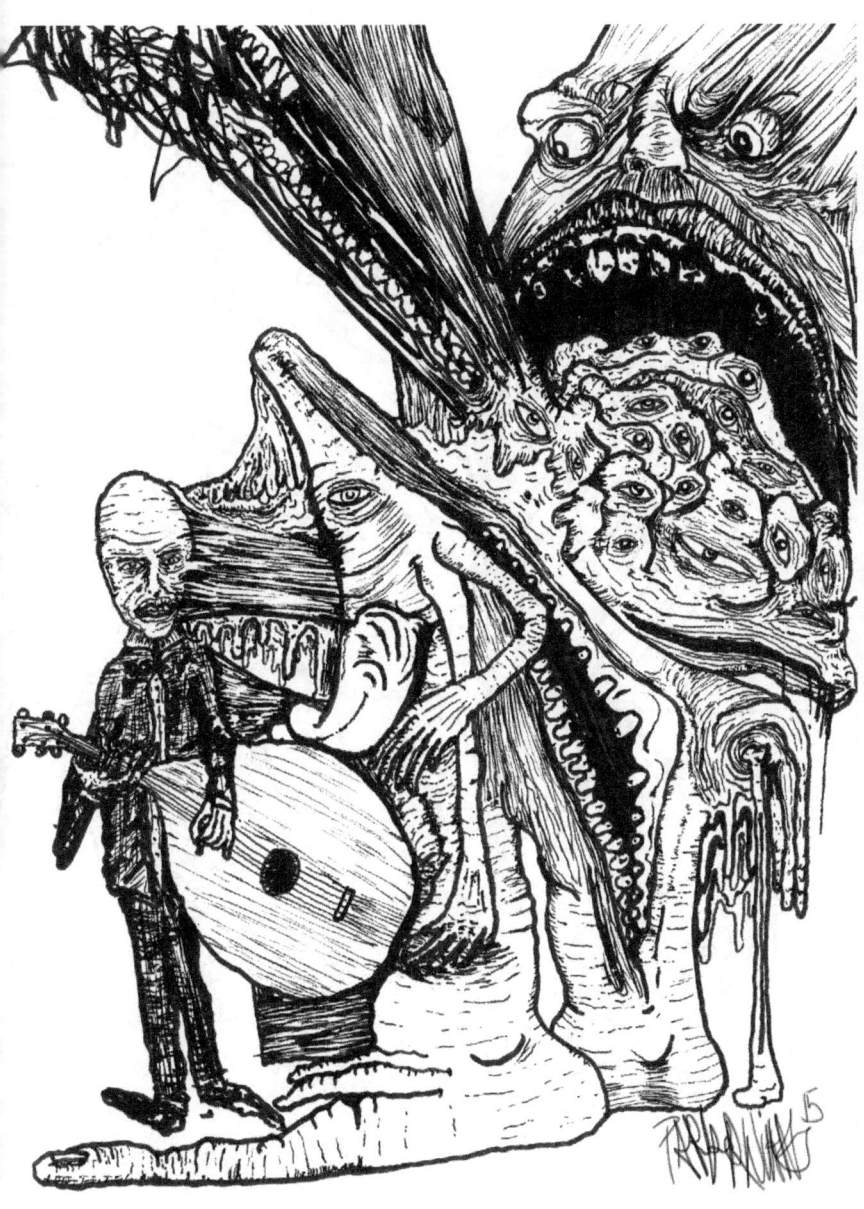

The Tune

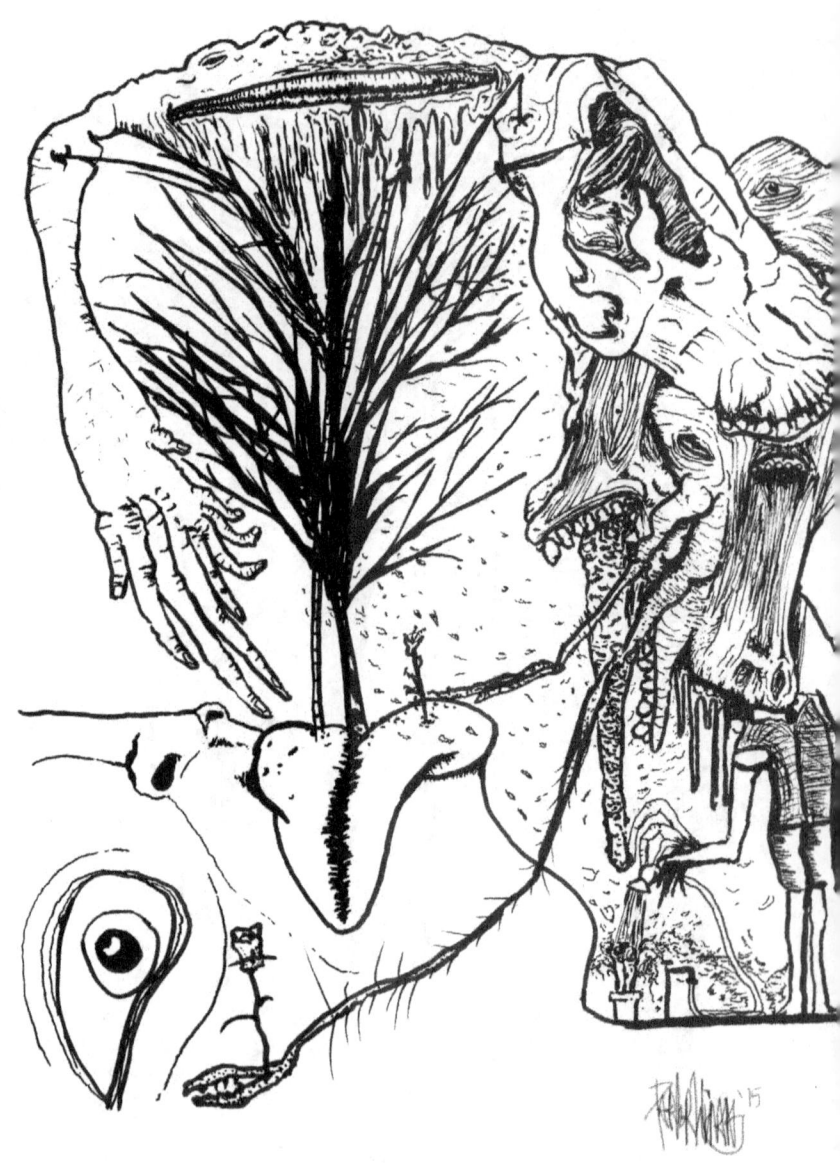

The Gardener

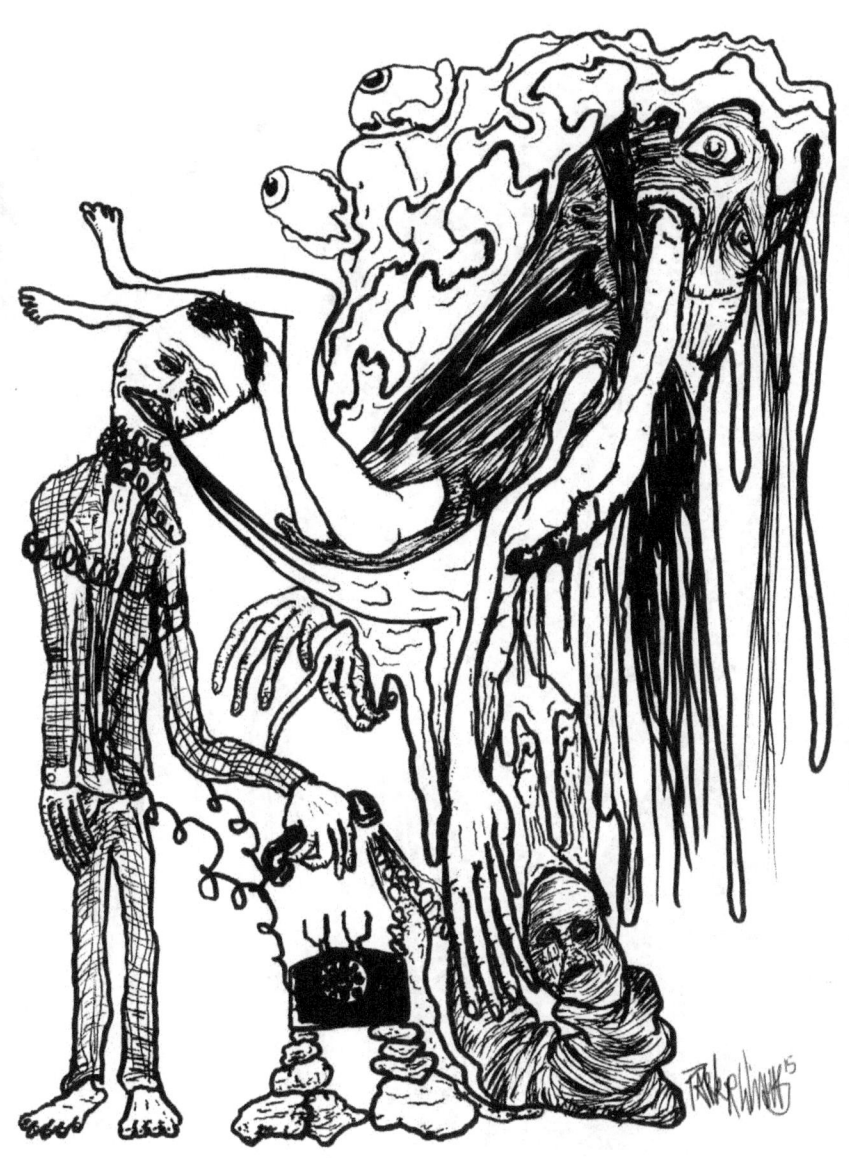

The Call

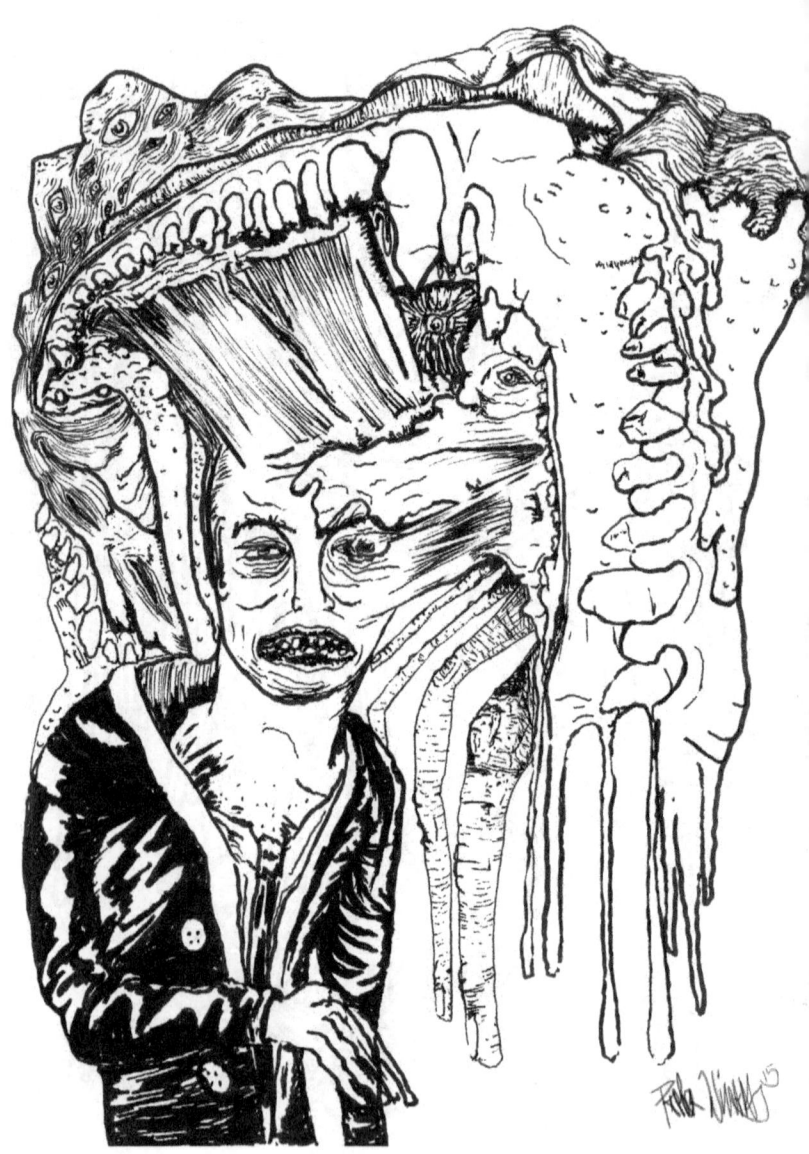

Lost In Thought

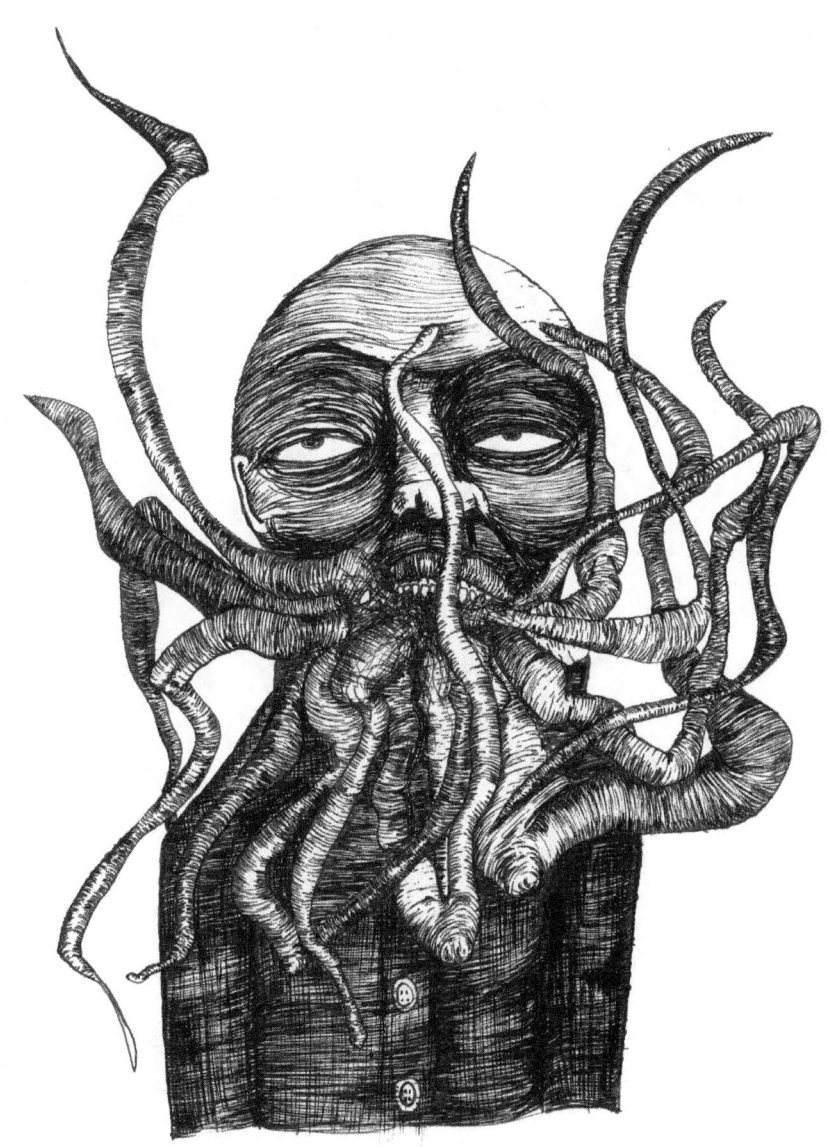

Mr. Scumchoir

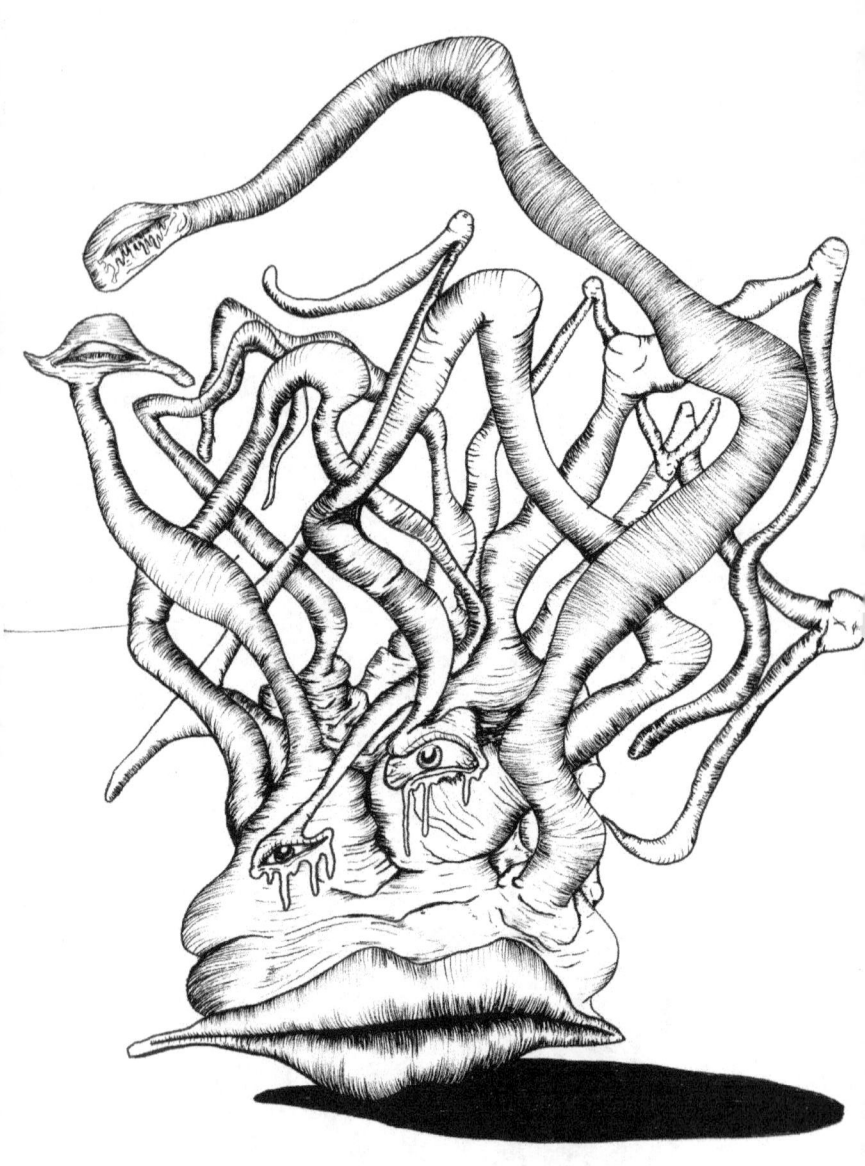

Tears

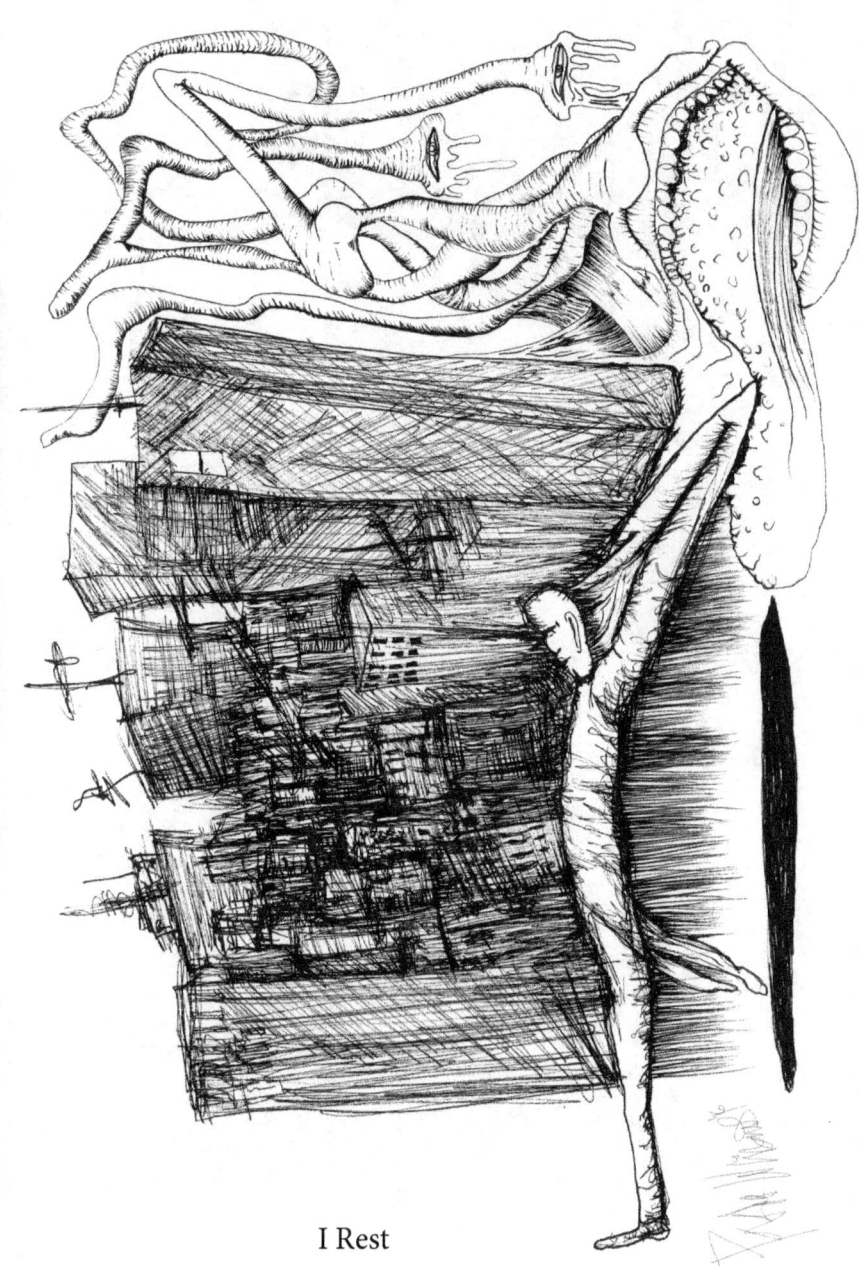

I Rest

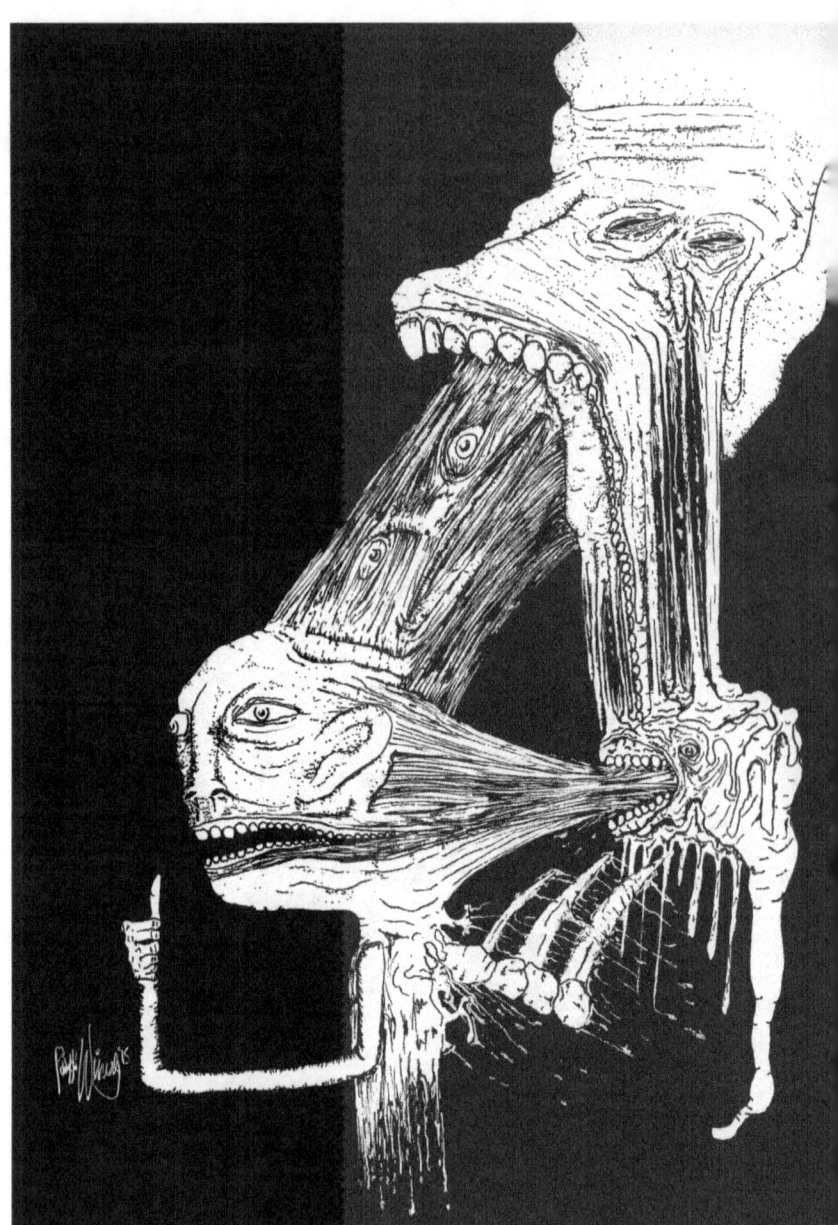

Okay

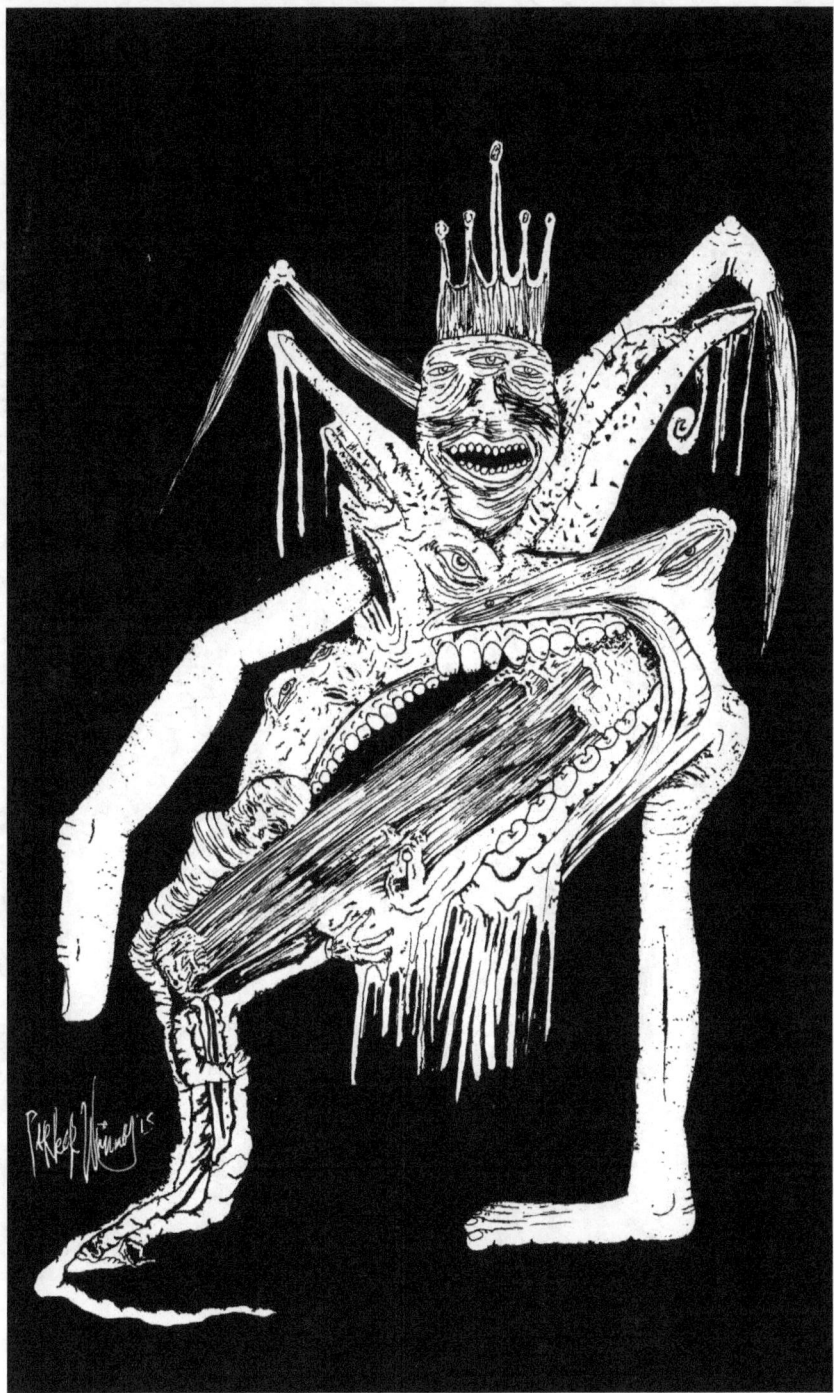

Reaching for the Key

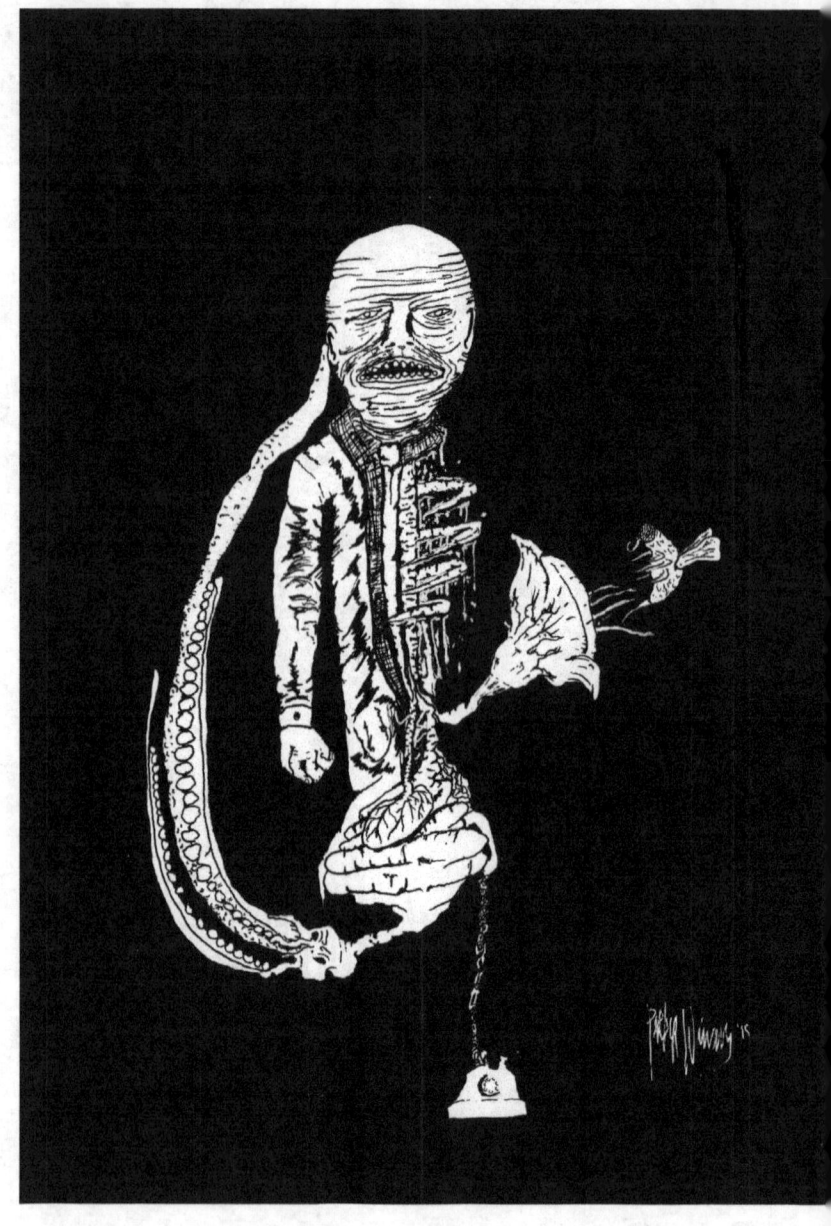

The Hang Up

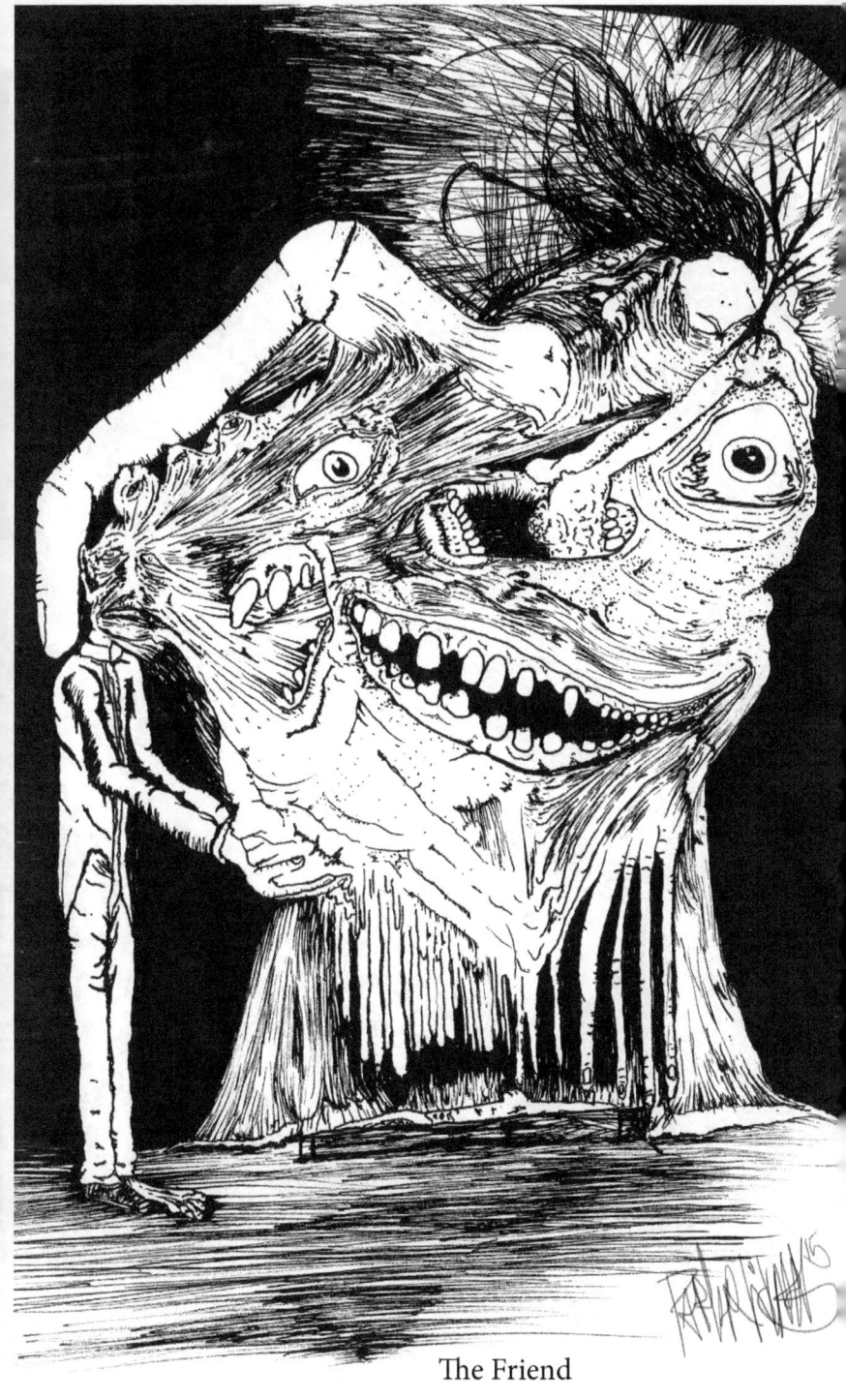

The Friend

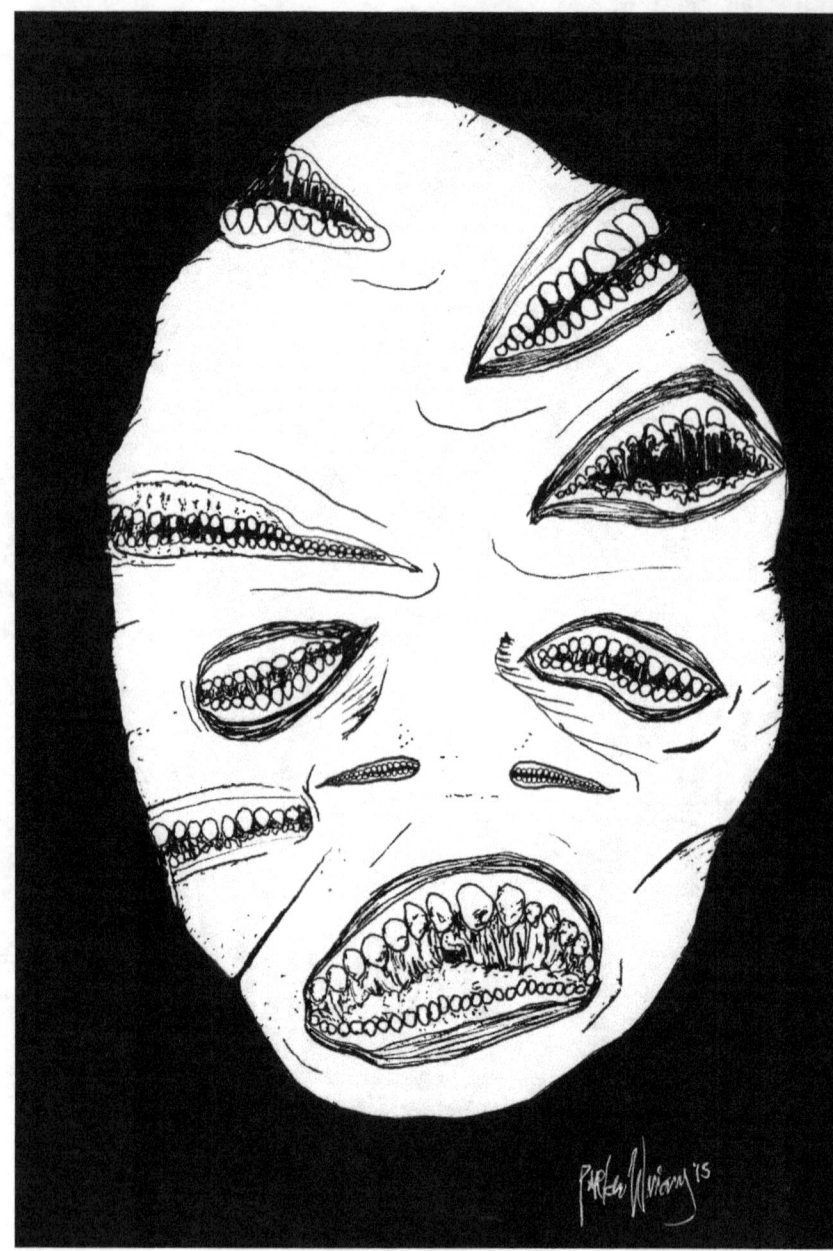

The Feeding

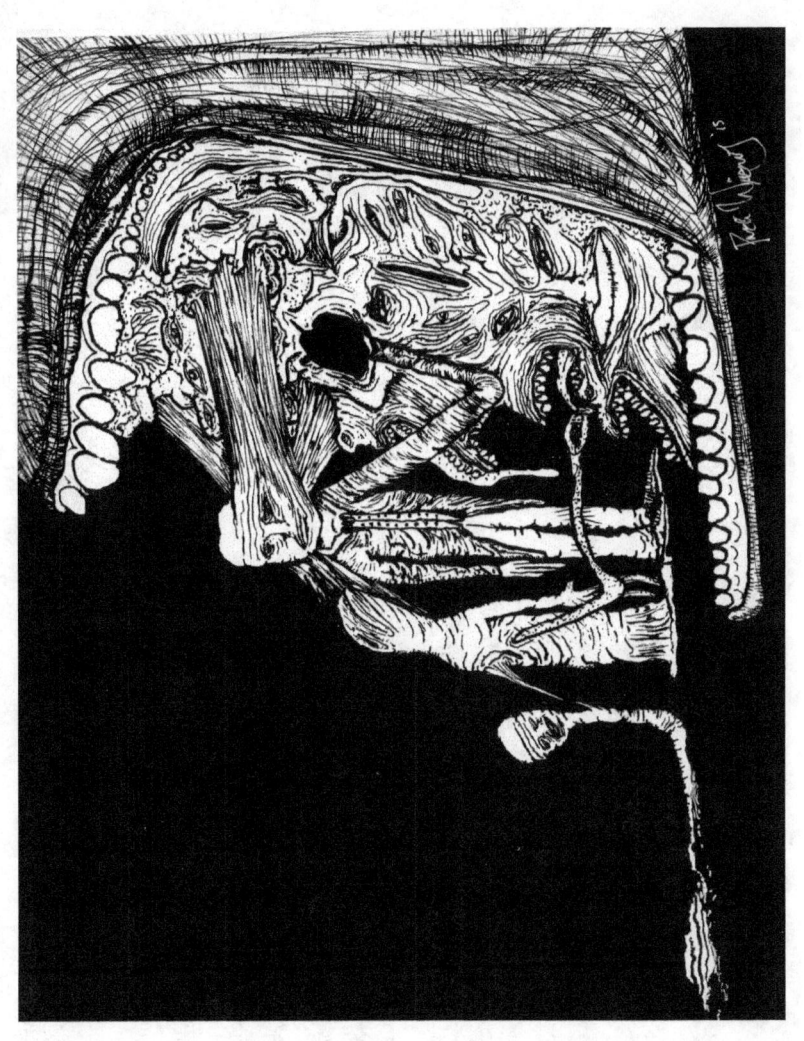

Evolving

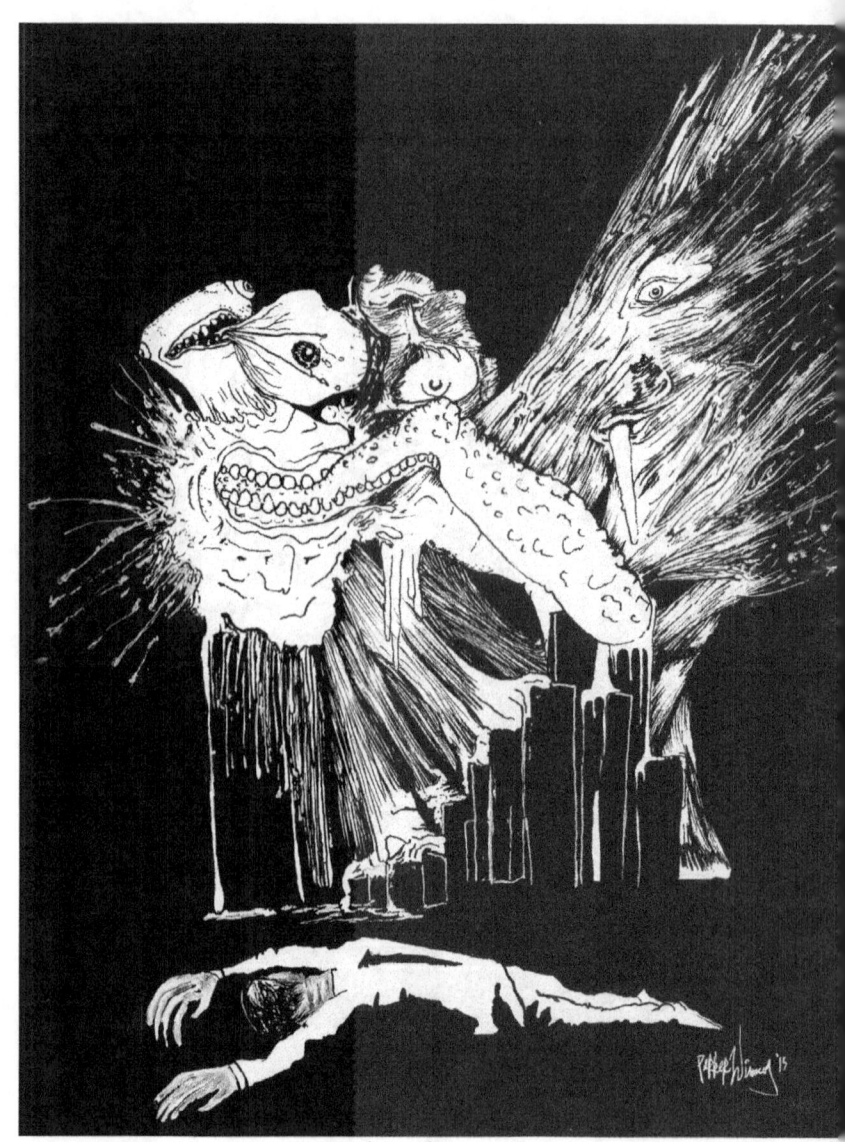

Wednesday

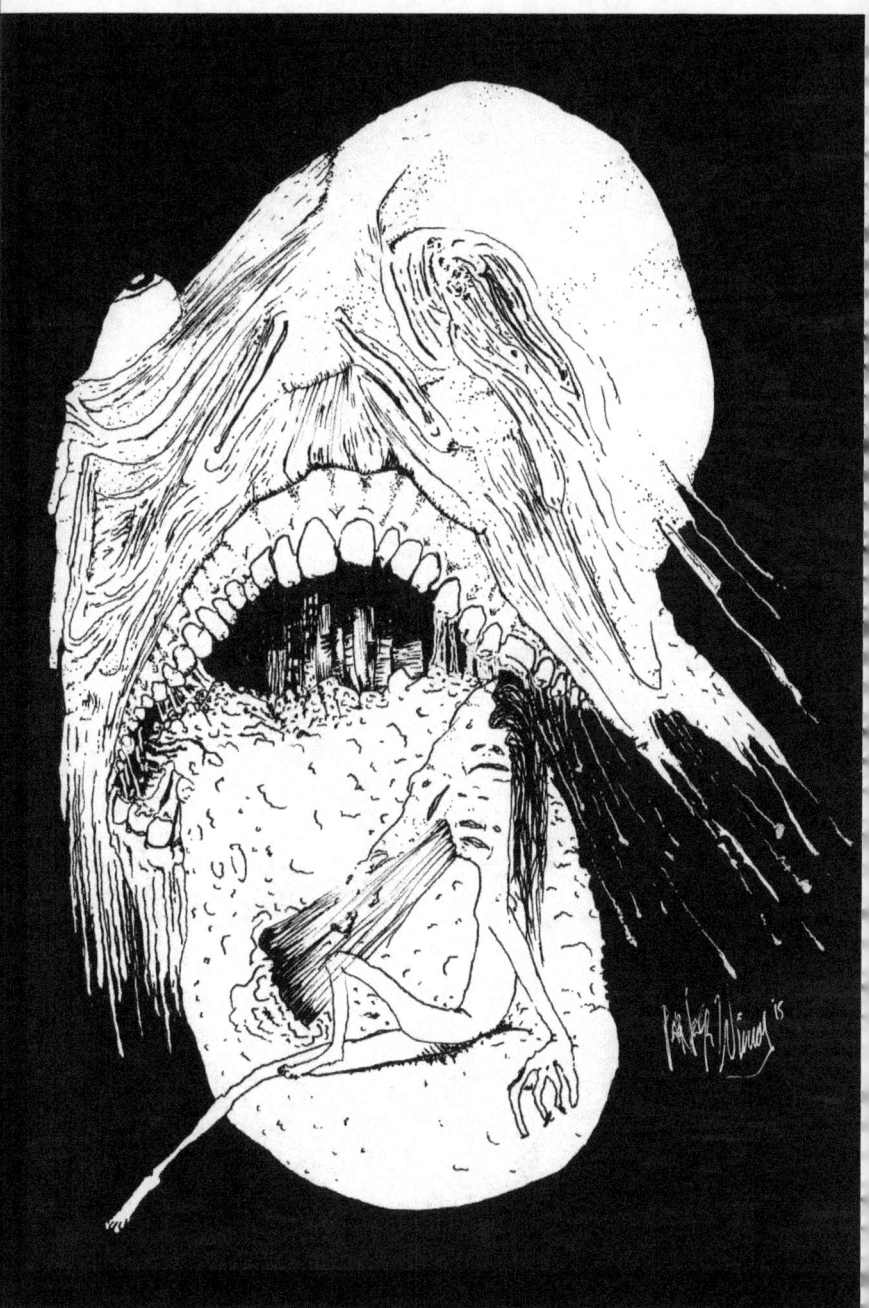

The Tongue

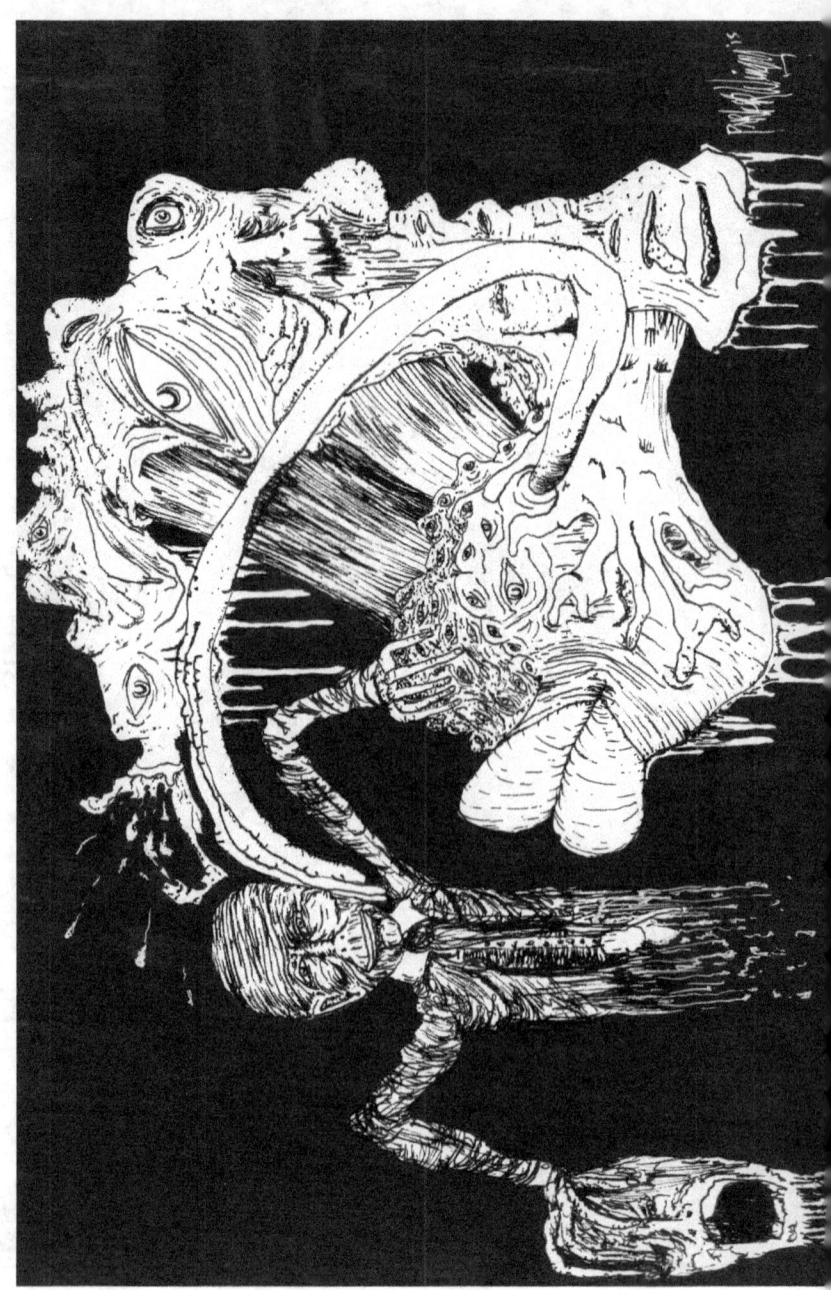

Severed

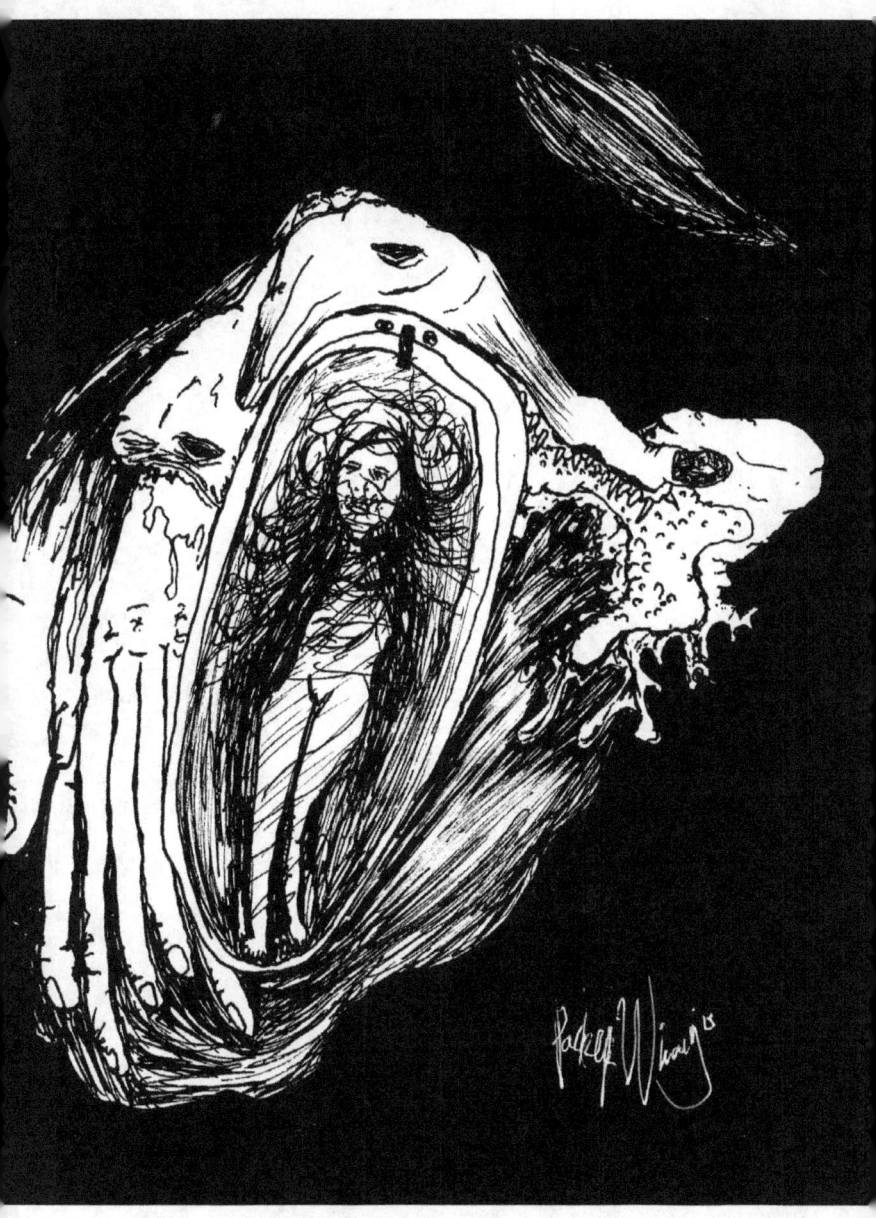

The Night Bath

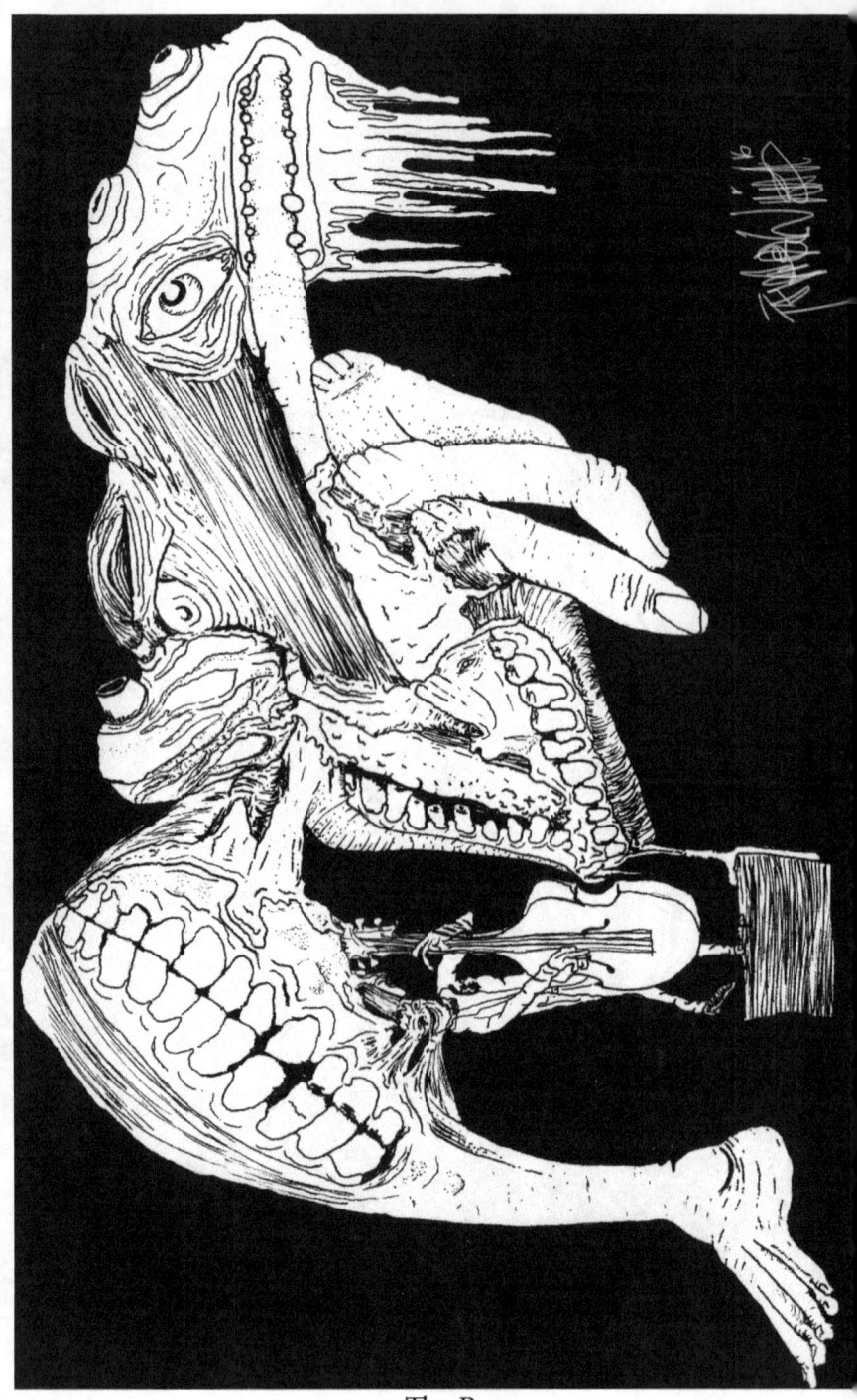

The Bass

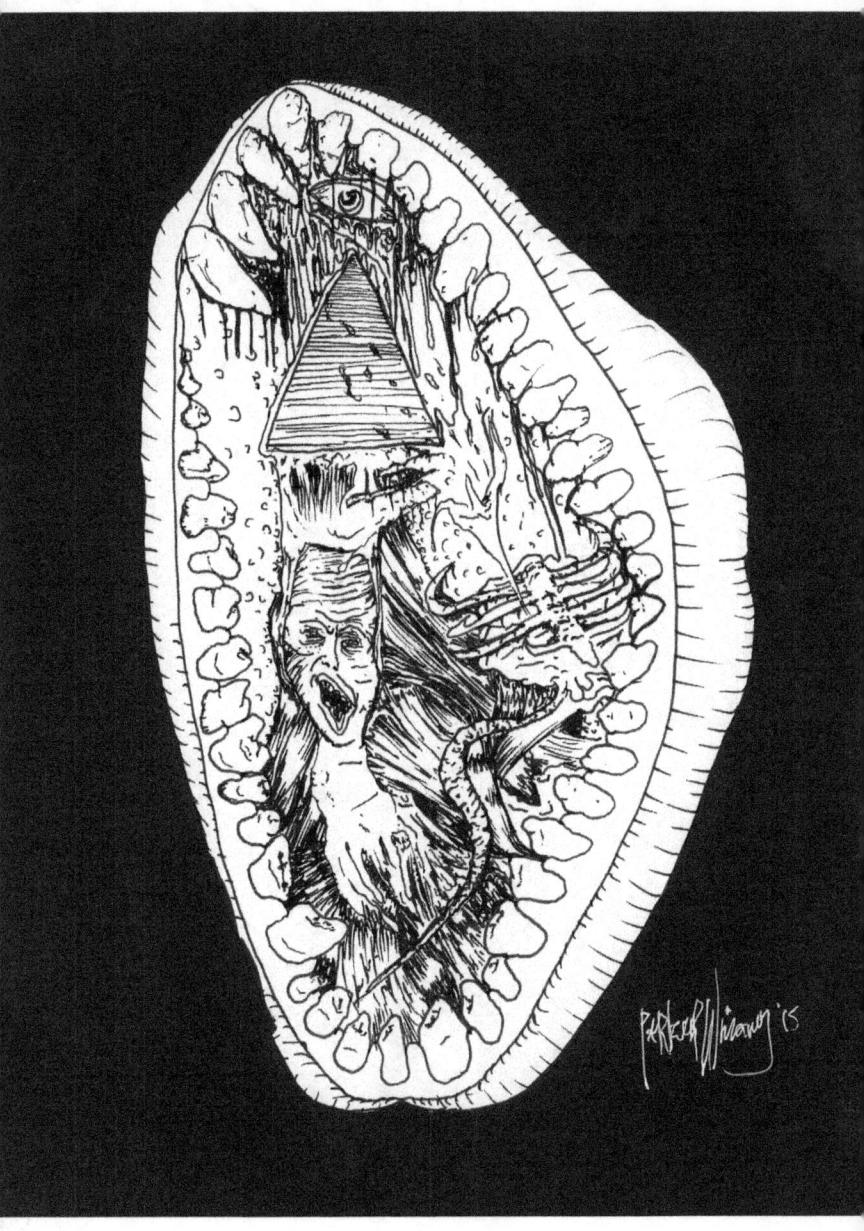

The Illuminati

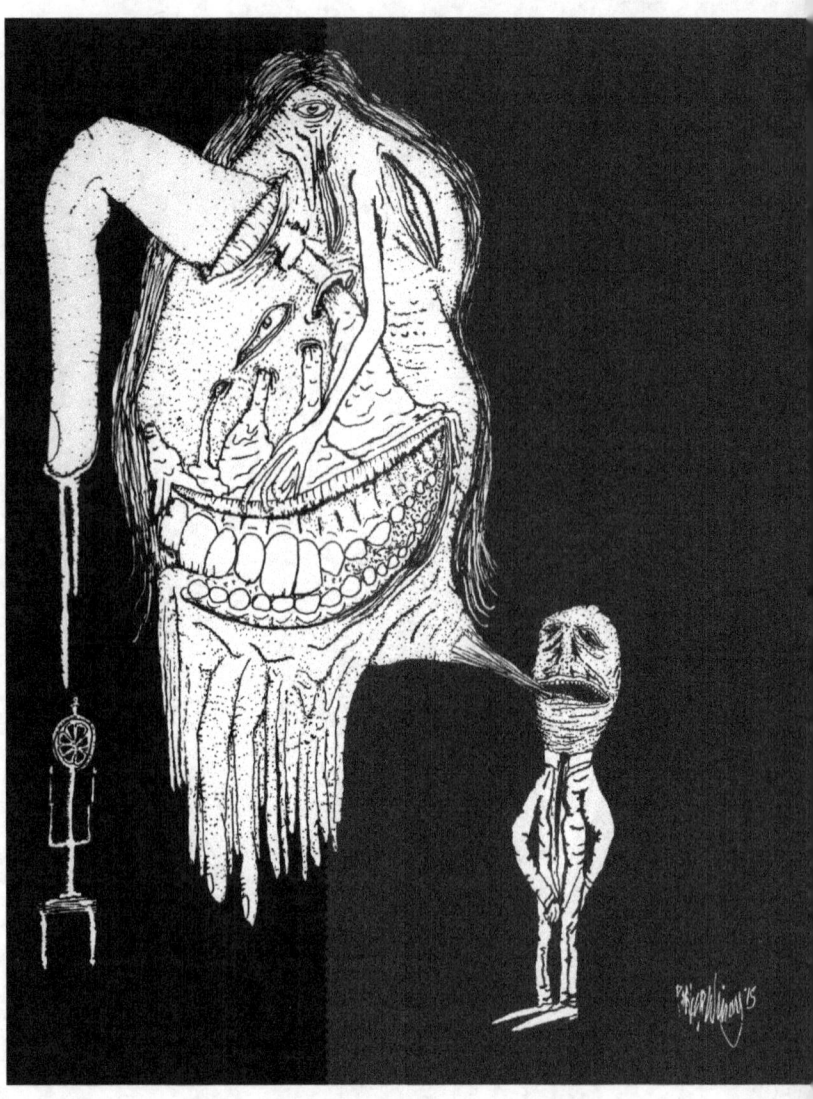

The Alter

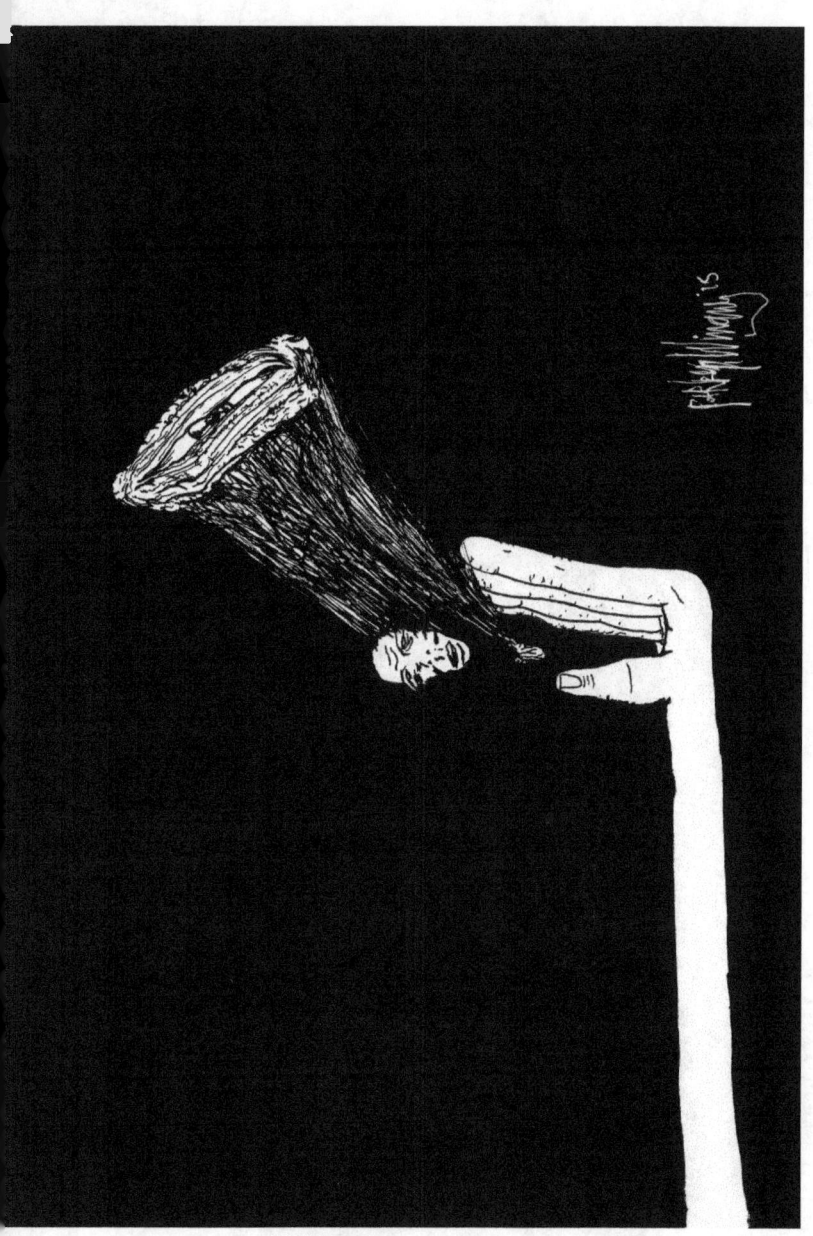

Hold Me

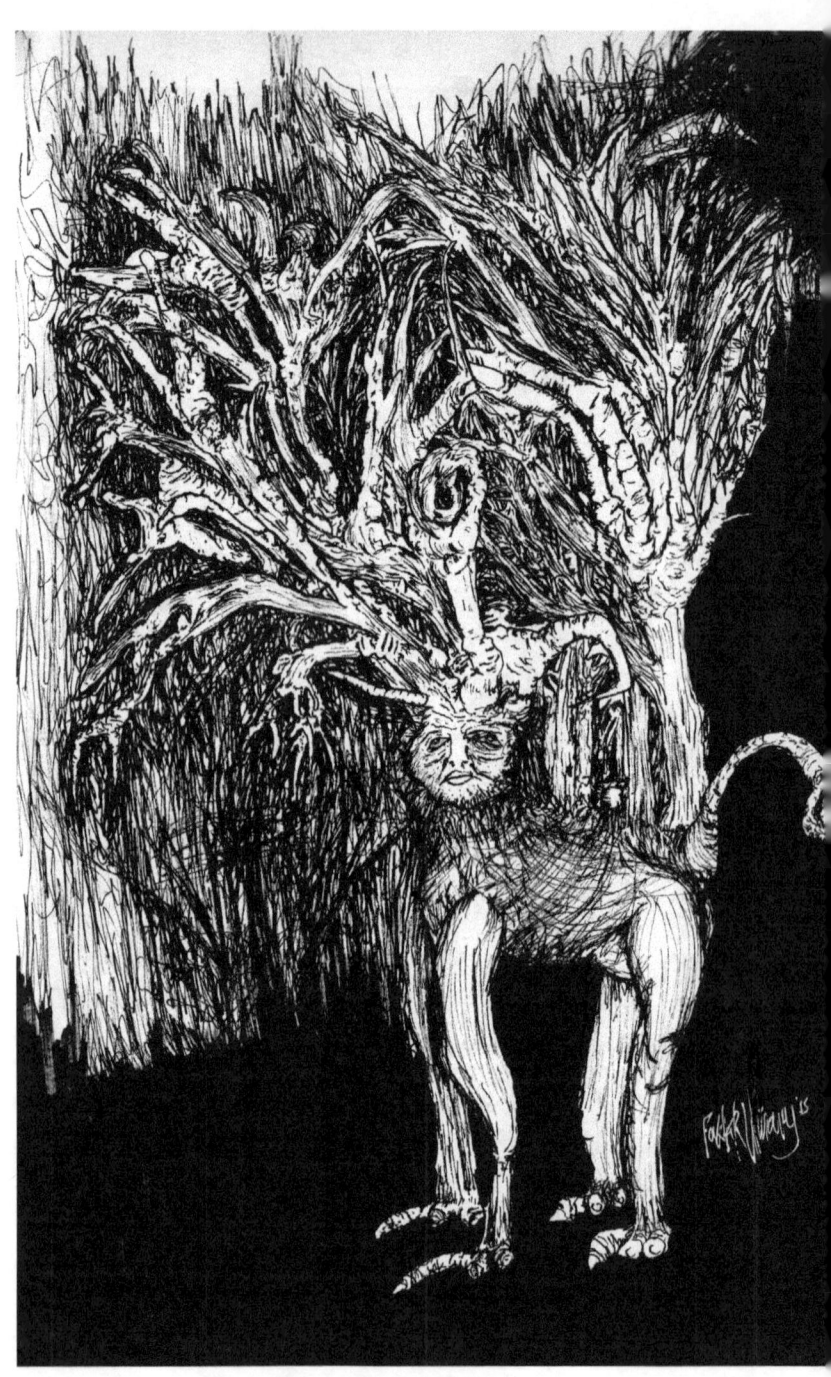

Mountain Dweller

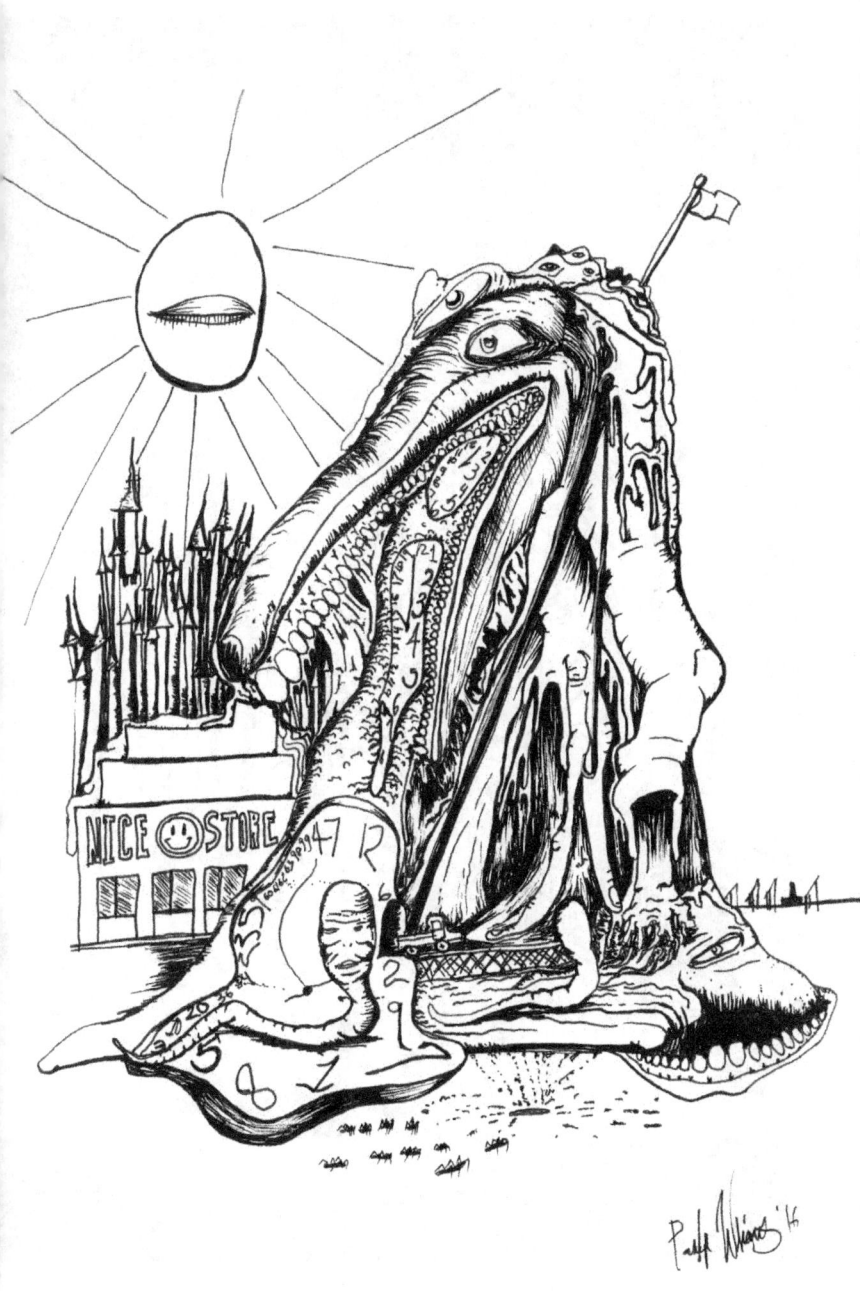

My Corporate Job

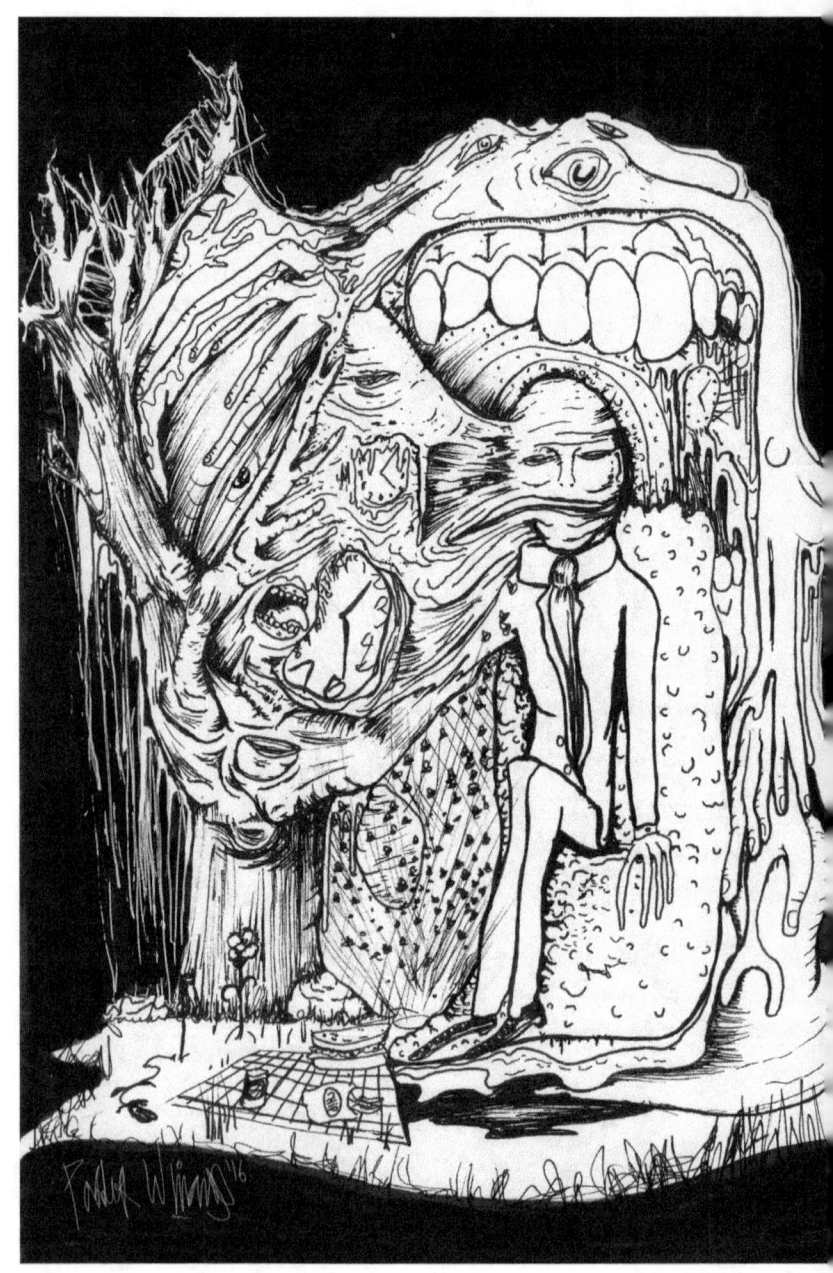

Lunchtime at the Hive

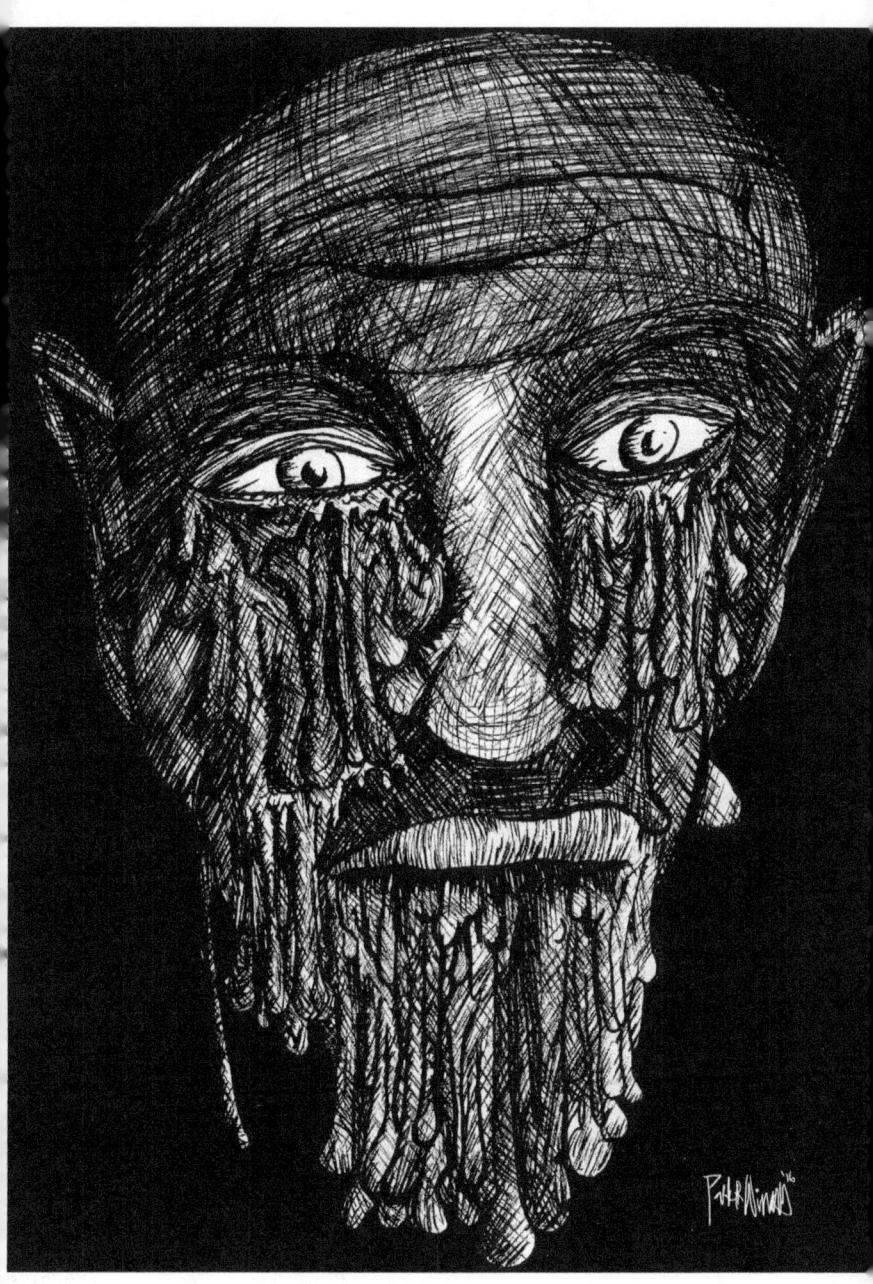

Old Man

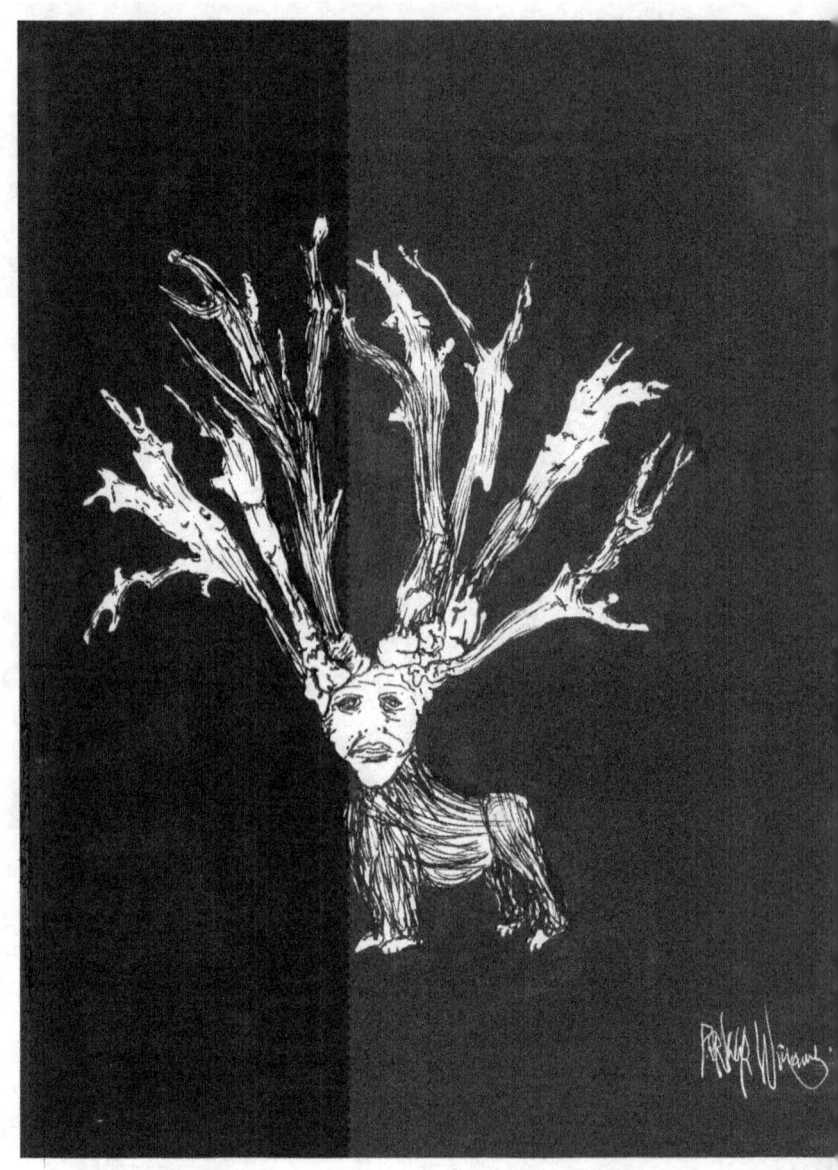

Little Brother

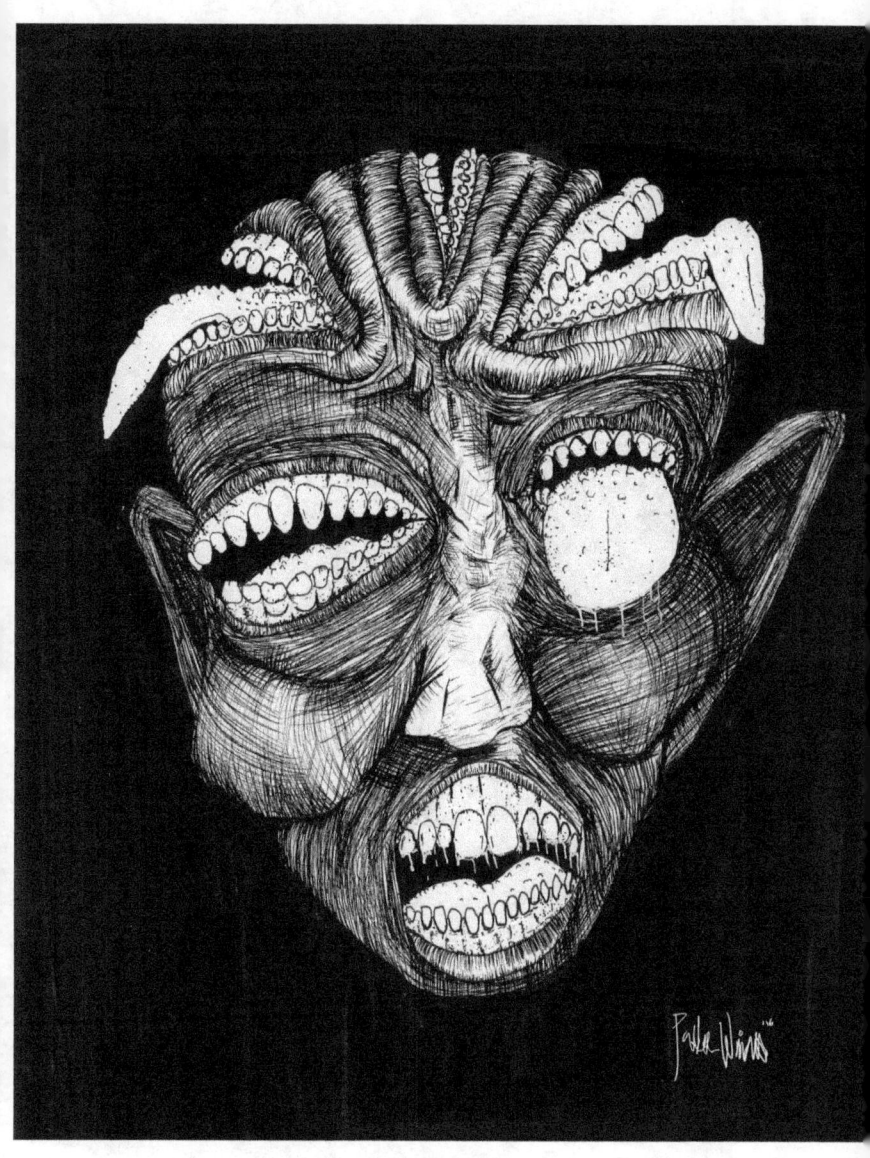

I'm Hungry

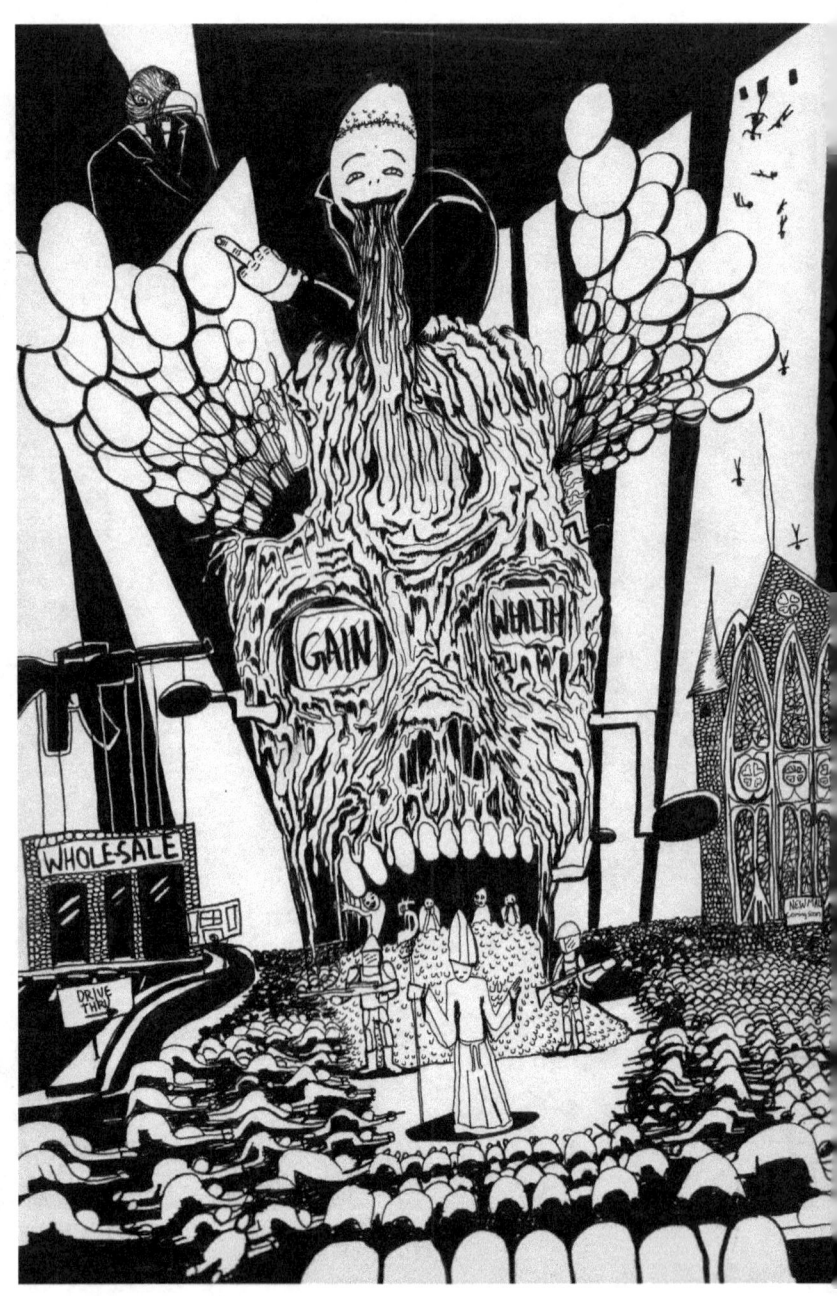

Reflection 1 of the 2016 presidential election

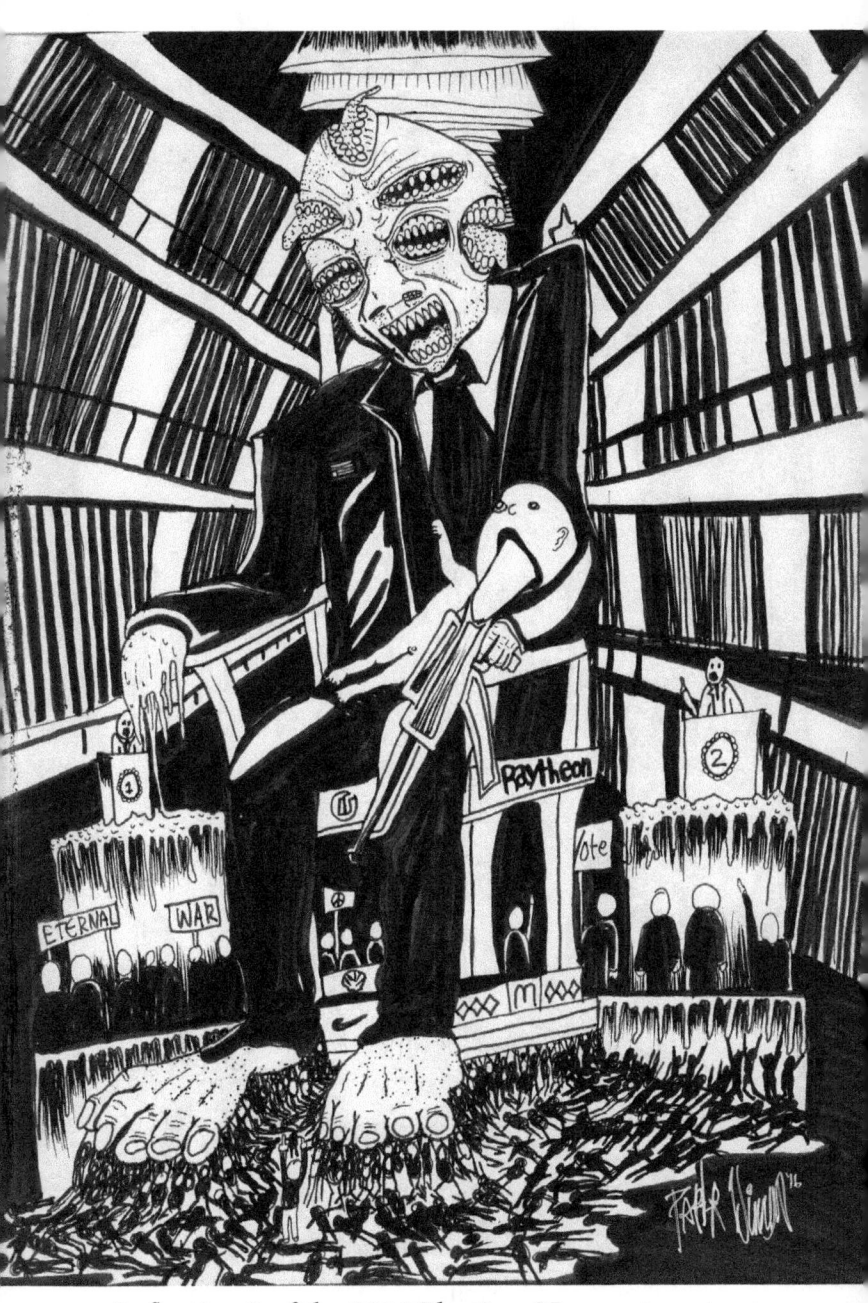

Reflection 2 of the 2016 Election: No way to vote against them

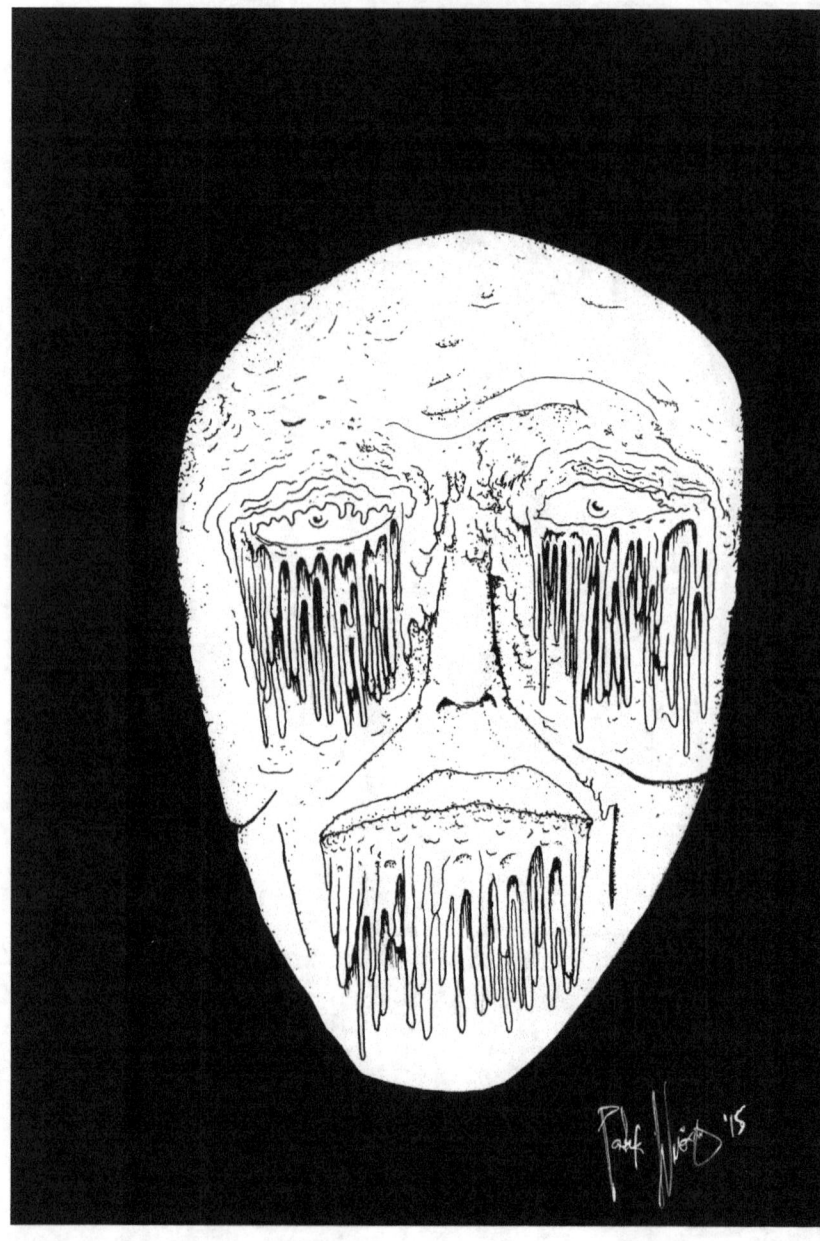

Melt

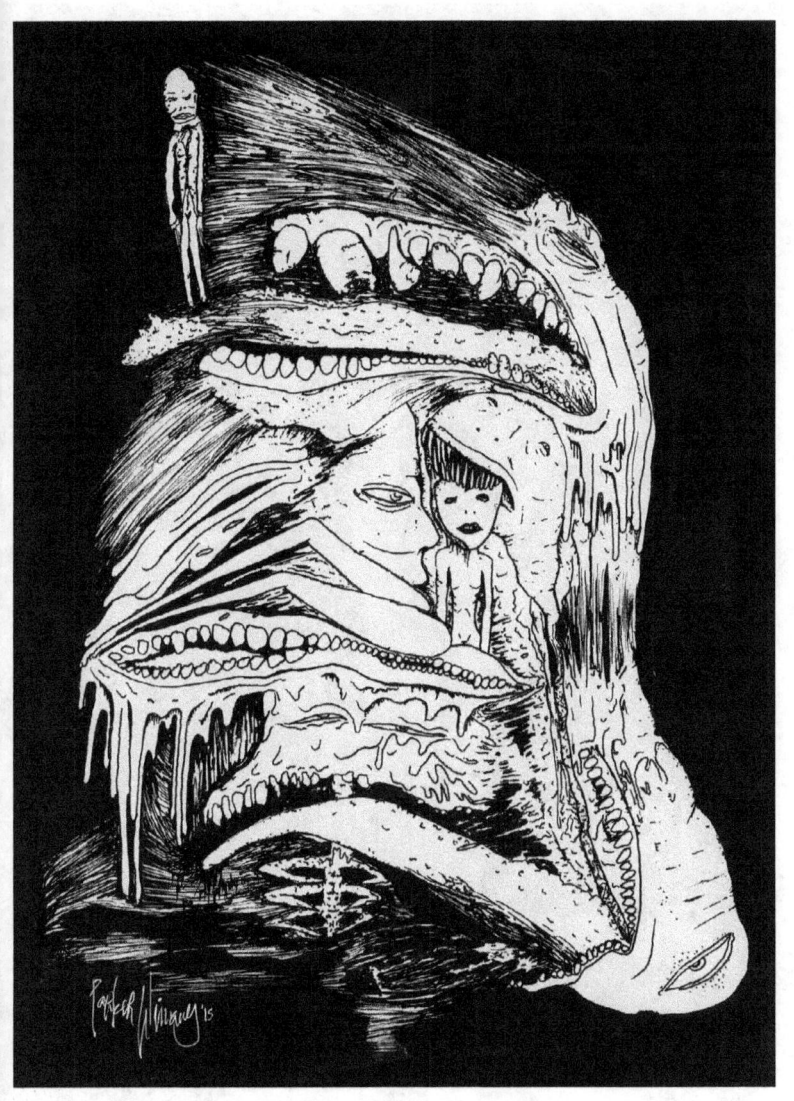

The Dream Watches

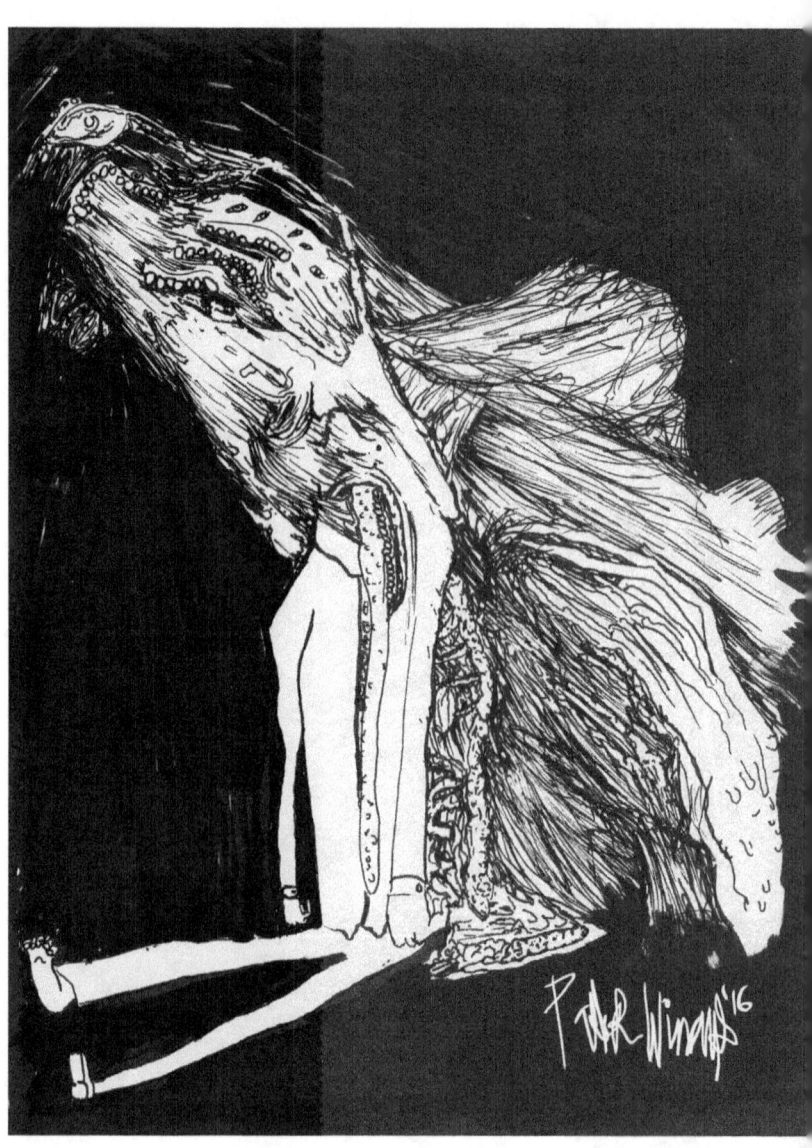

The Right Food

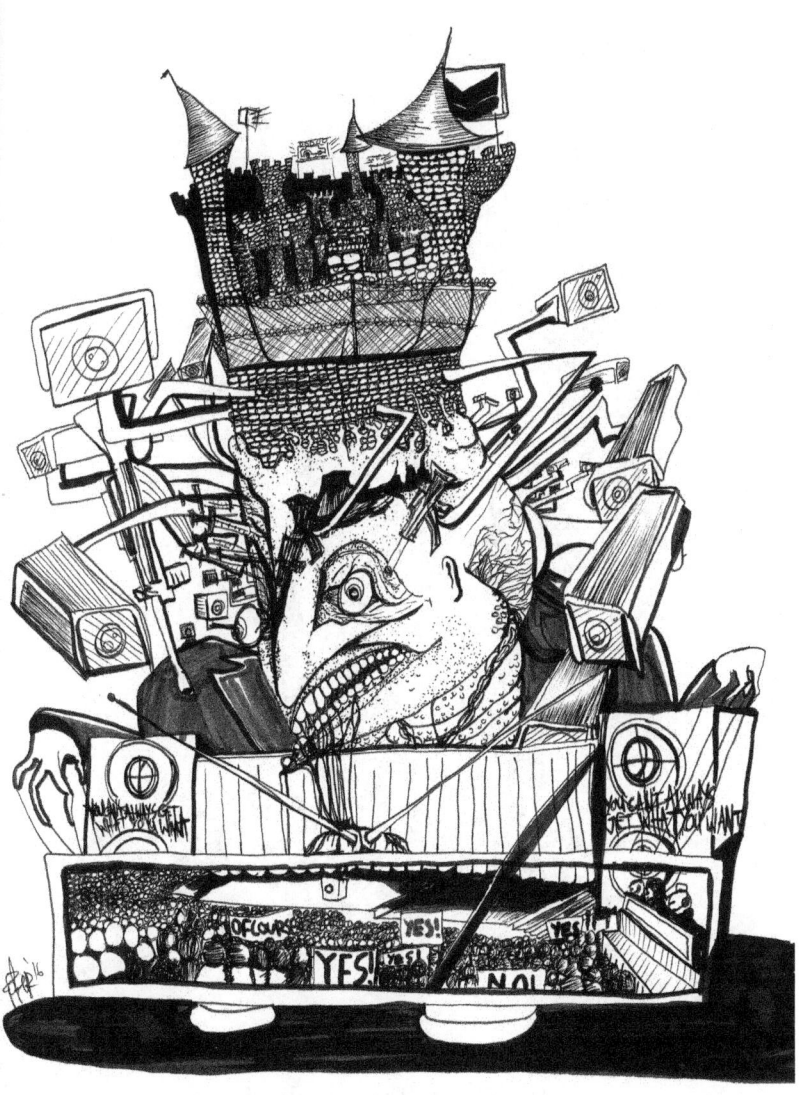

Reflection 3 of the 2016 Presidential Election - DNC "You Can't Always Get What you Want"

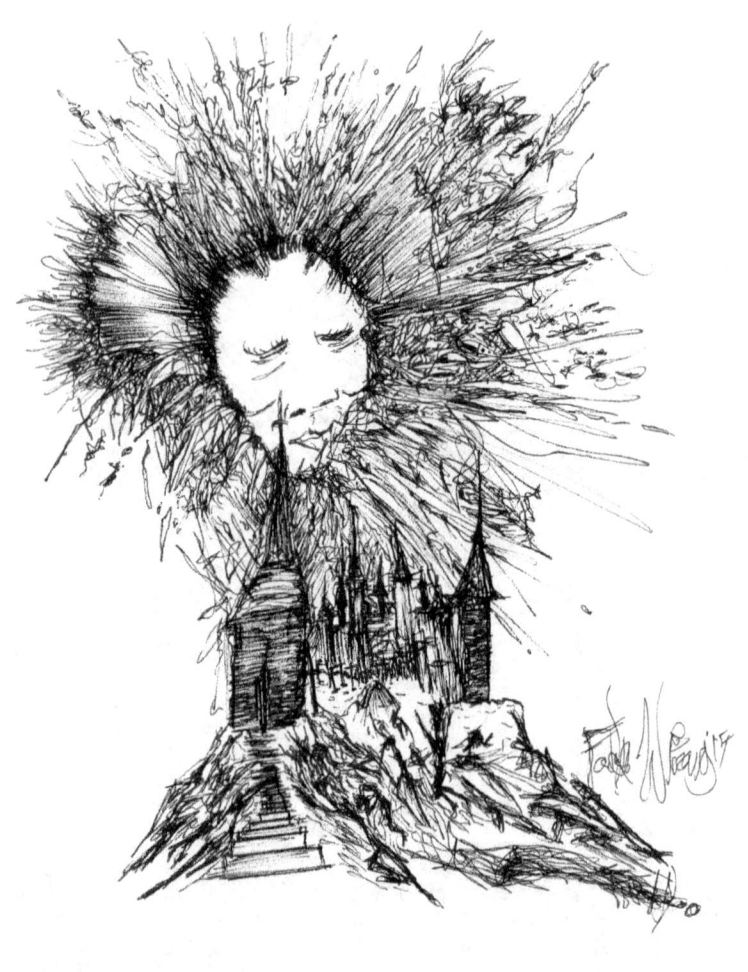

The Earth, The People, The Sun

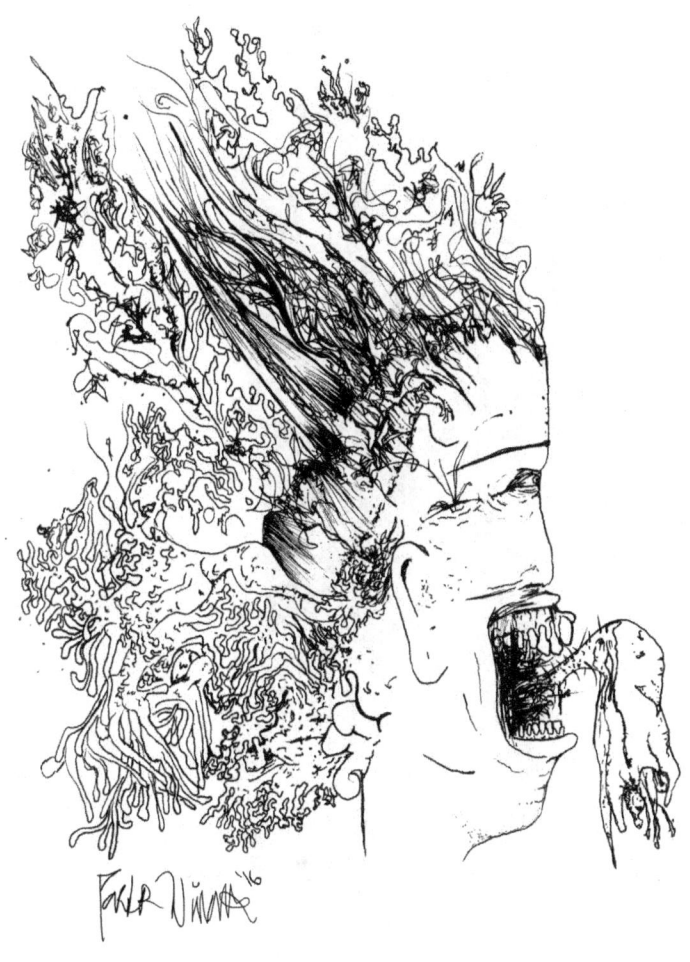

Plant Based Diet

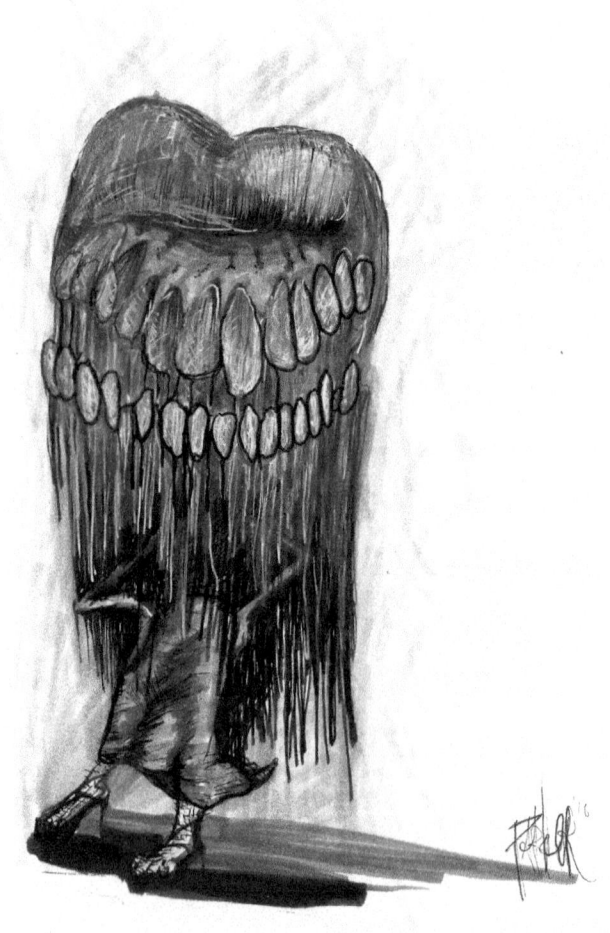

Attitude

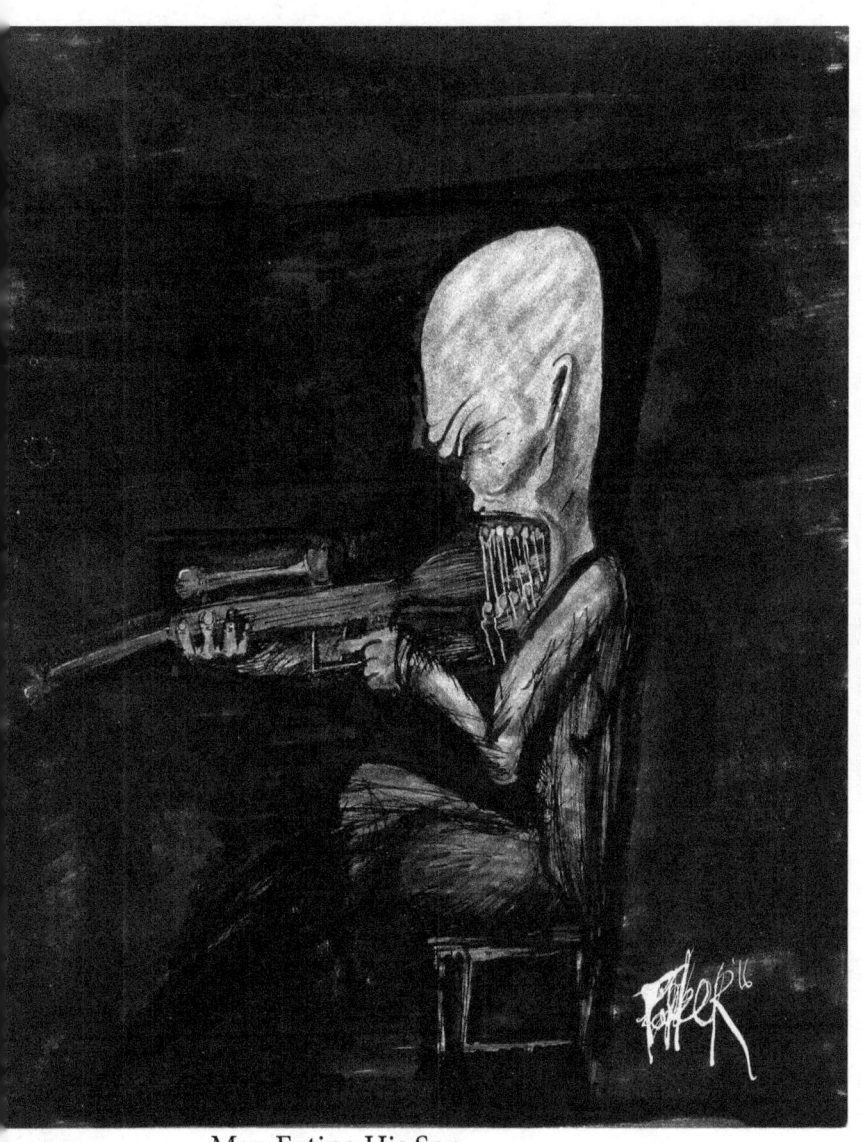

Man Eating His Son

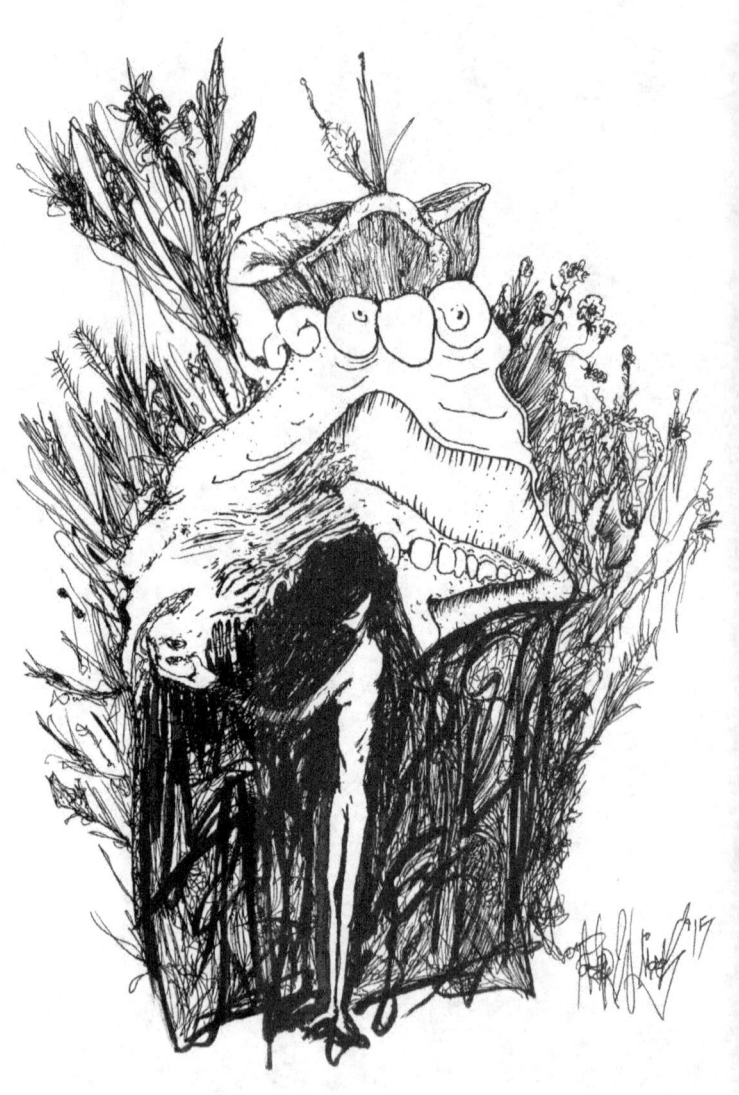

Eve

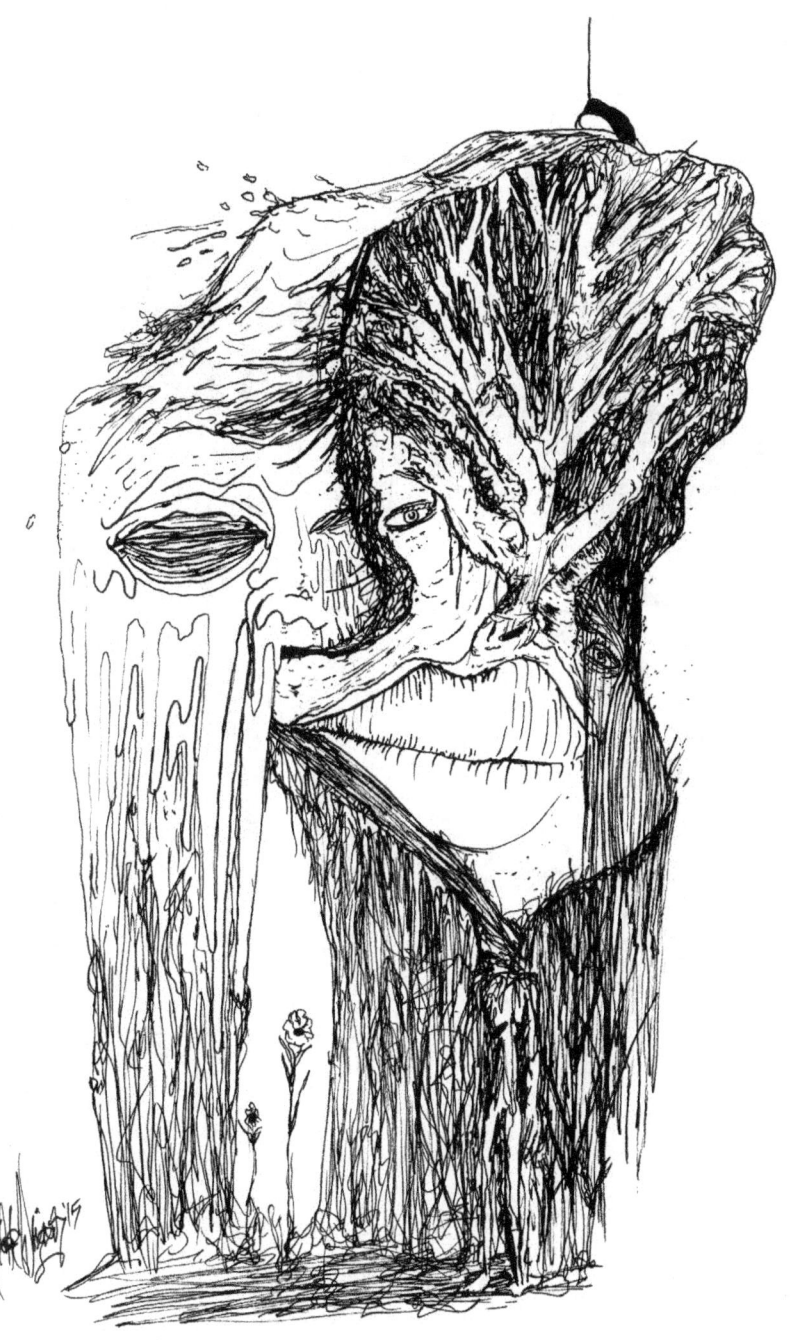

Eden

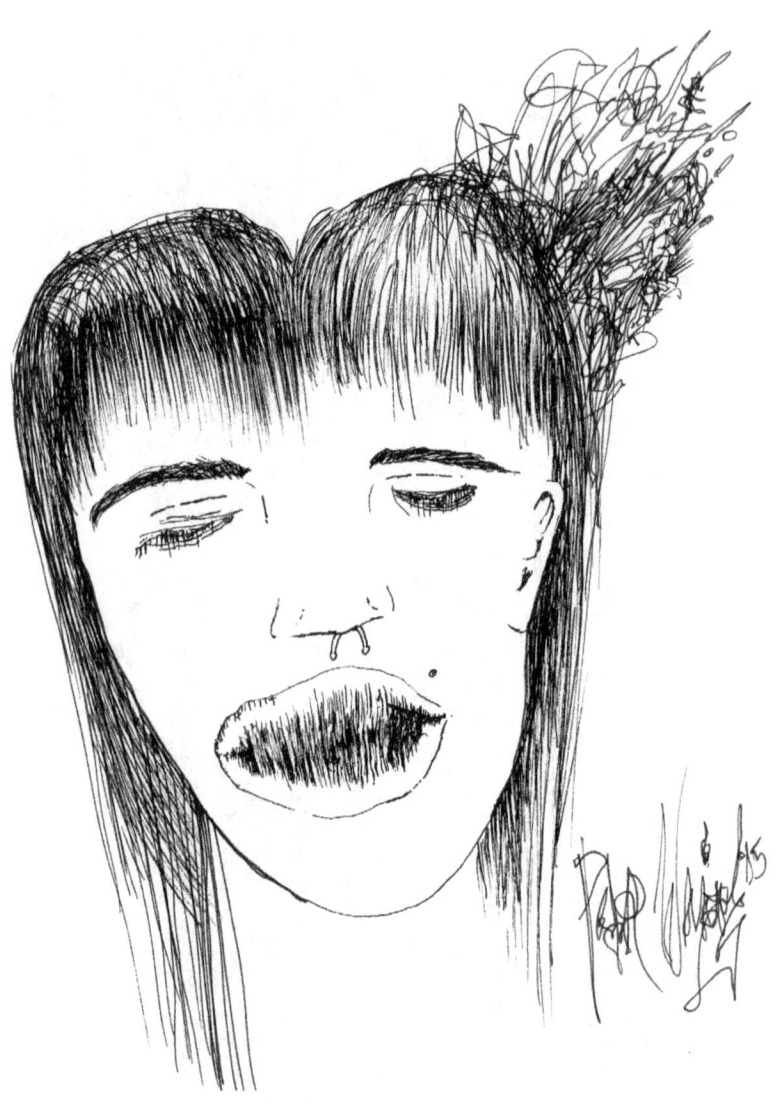

Satanic Nympho

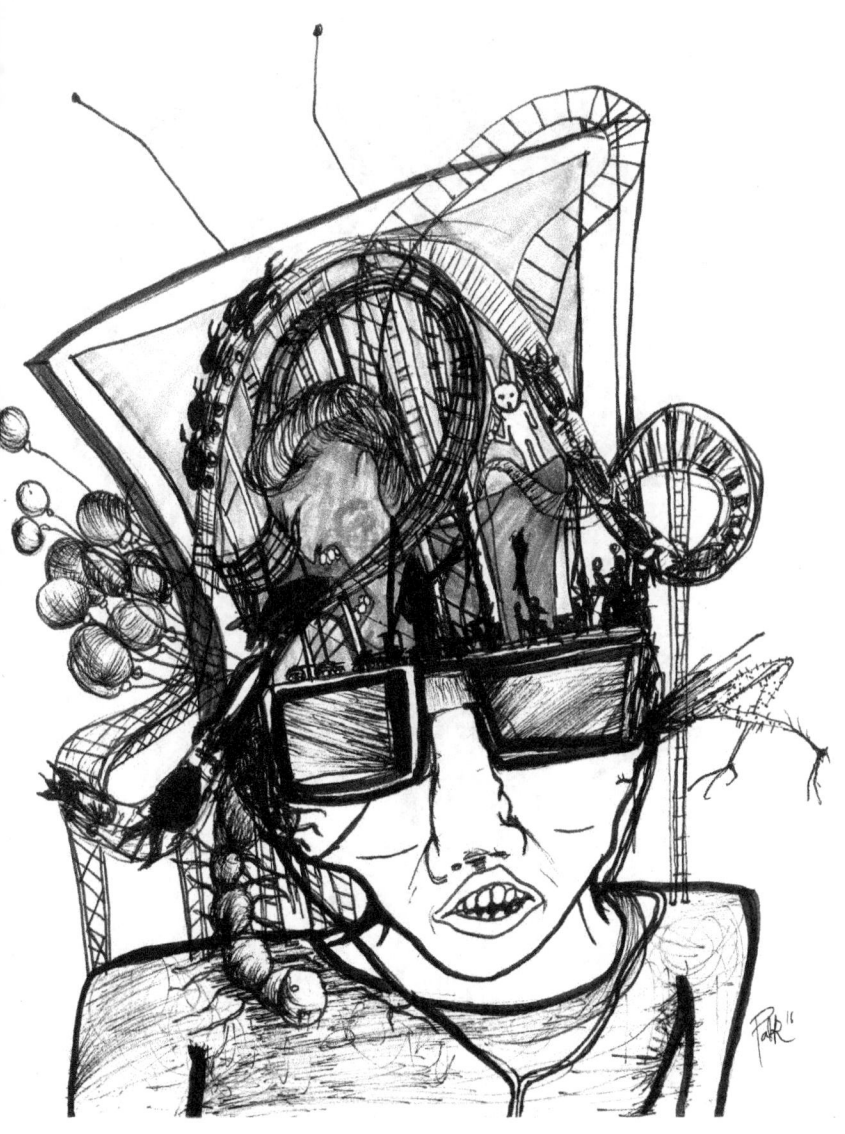

Reflection 4 of the 2016 Presidential Election: The Most Destructive form of Entertainment

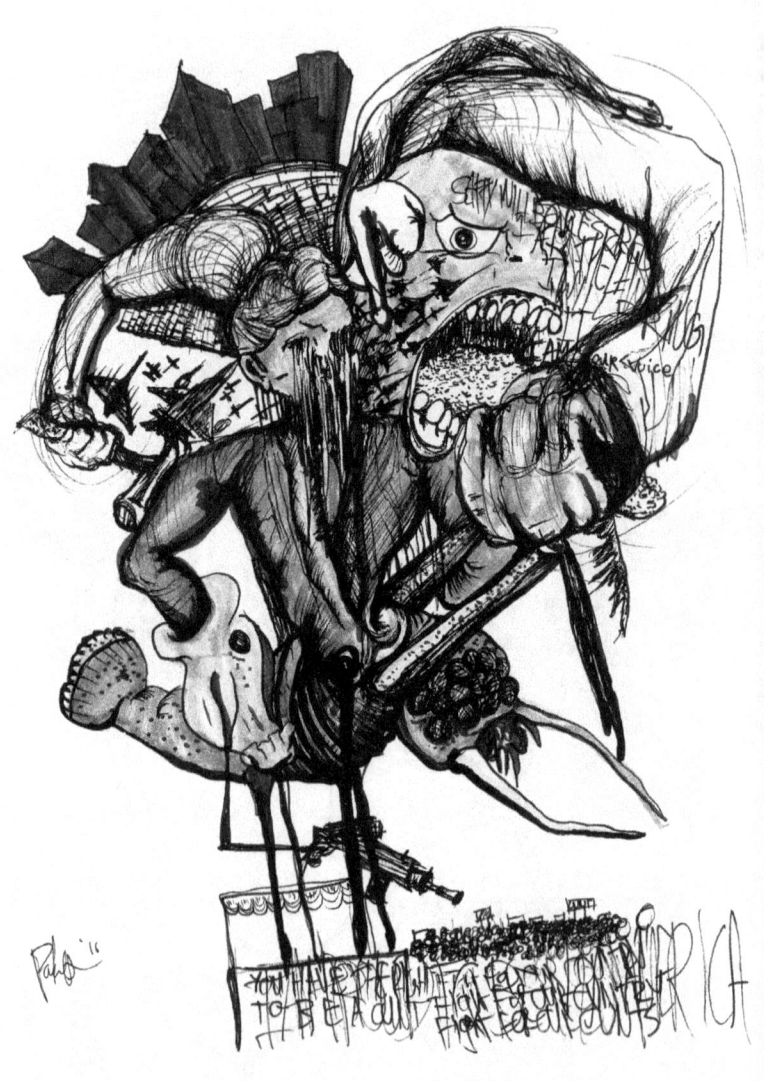

Reflection 5 of 2016 Presidential Election RNC: I'll Destroy more than anyone else on this Stage

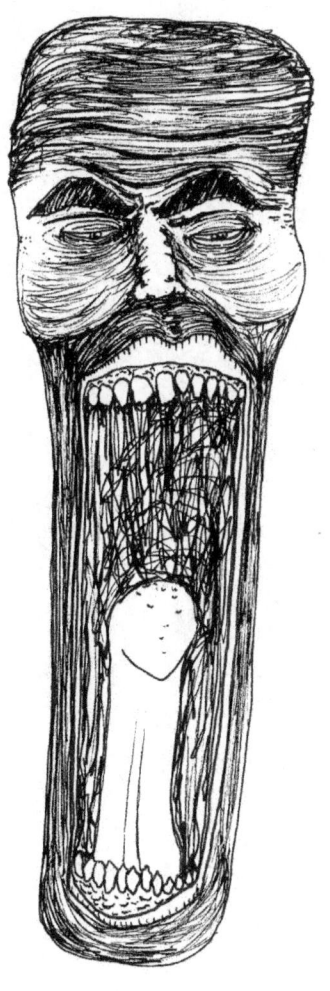

ahhhhhhhh!

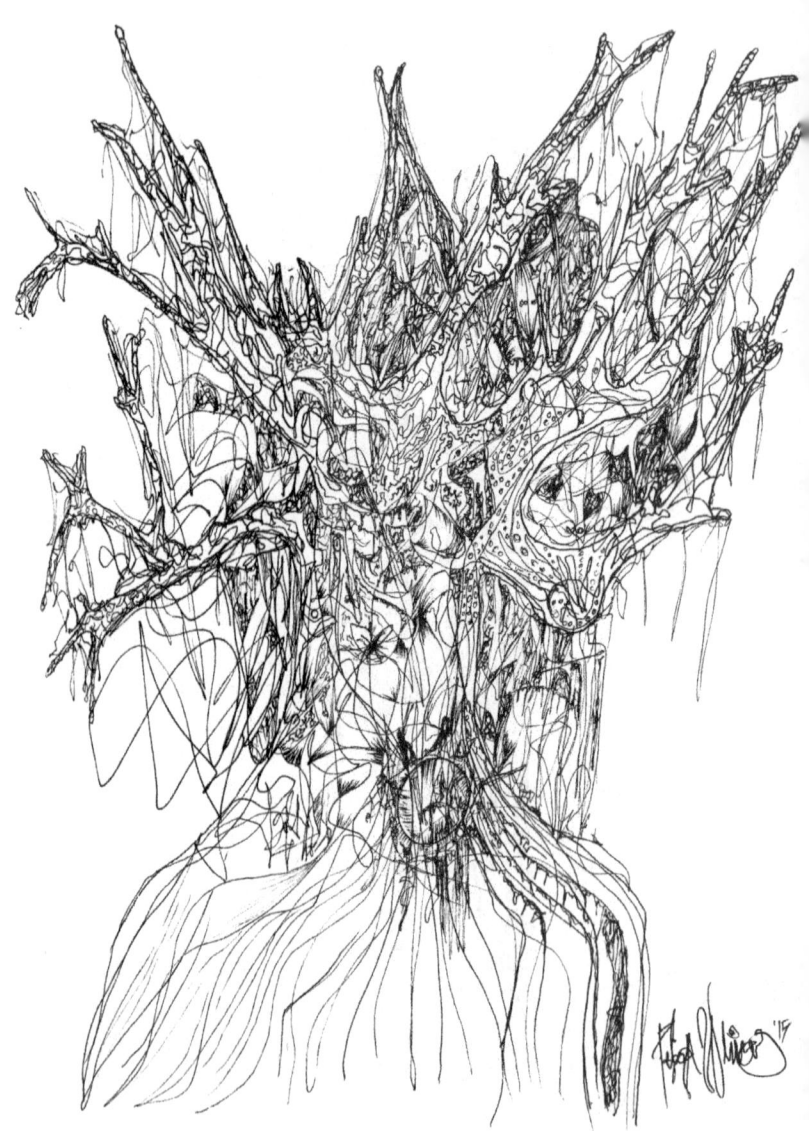

Mozart Exultation

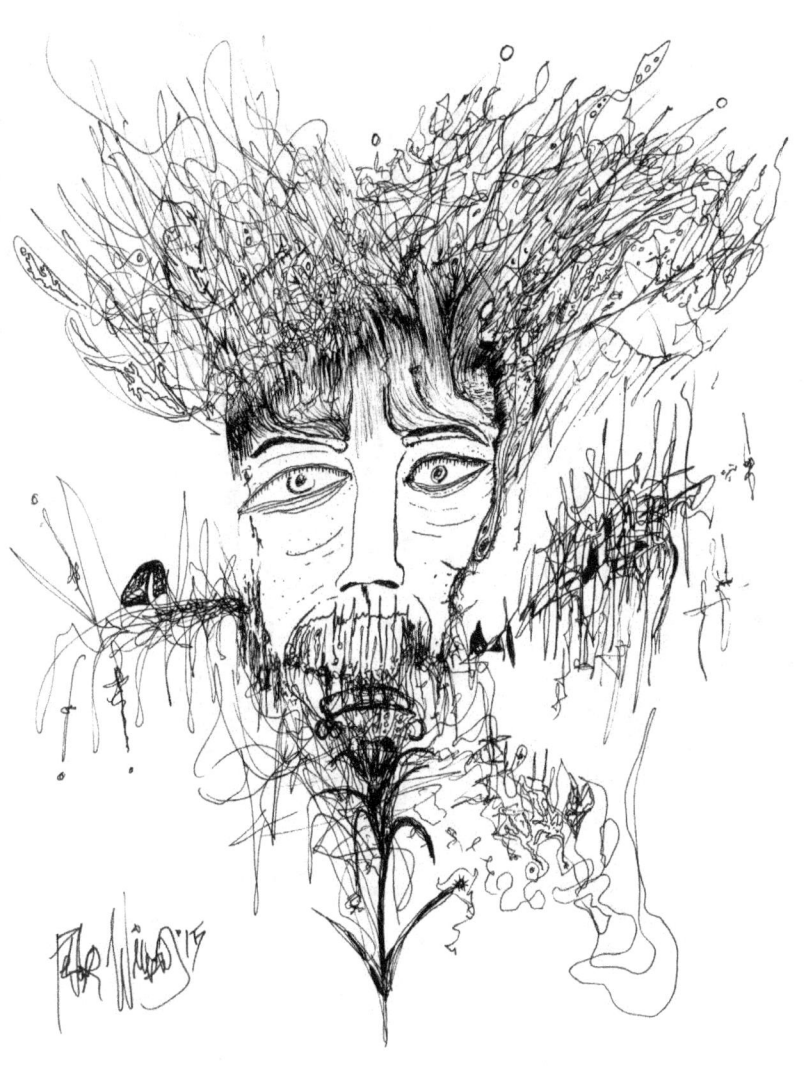

One with All

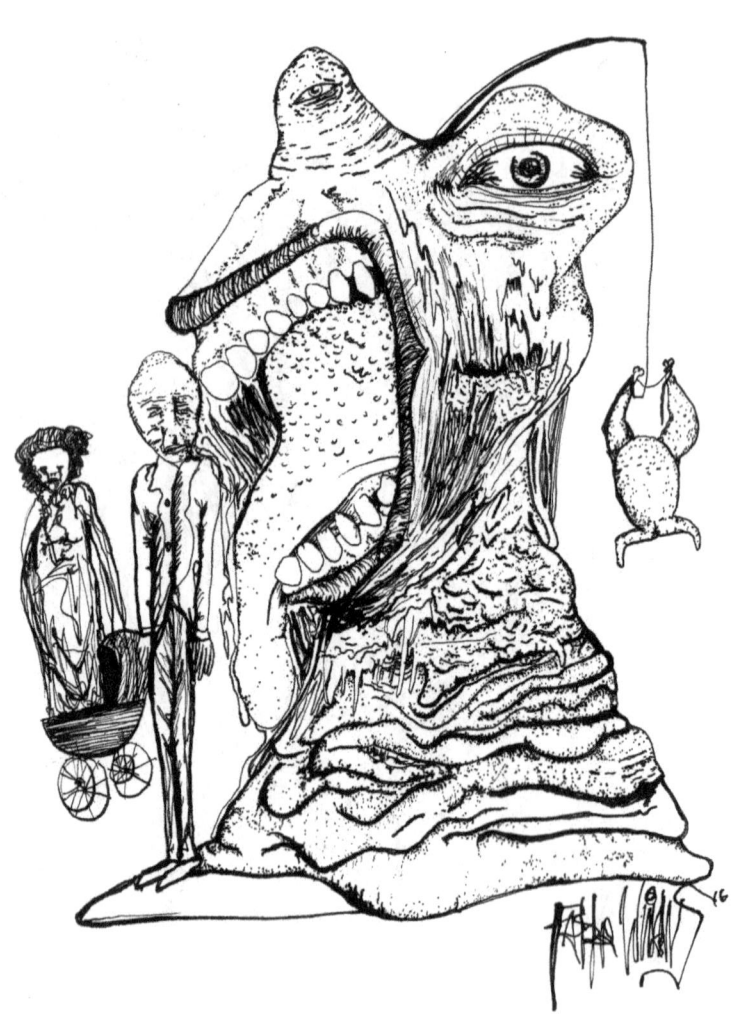

I Eat Chicken

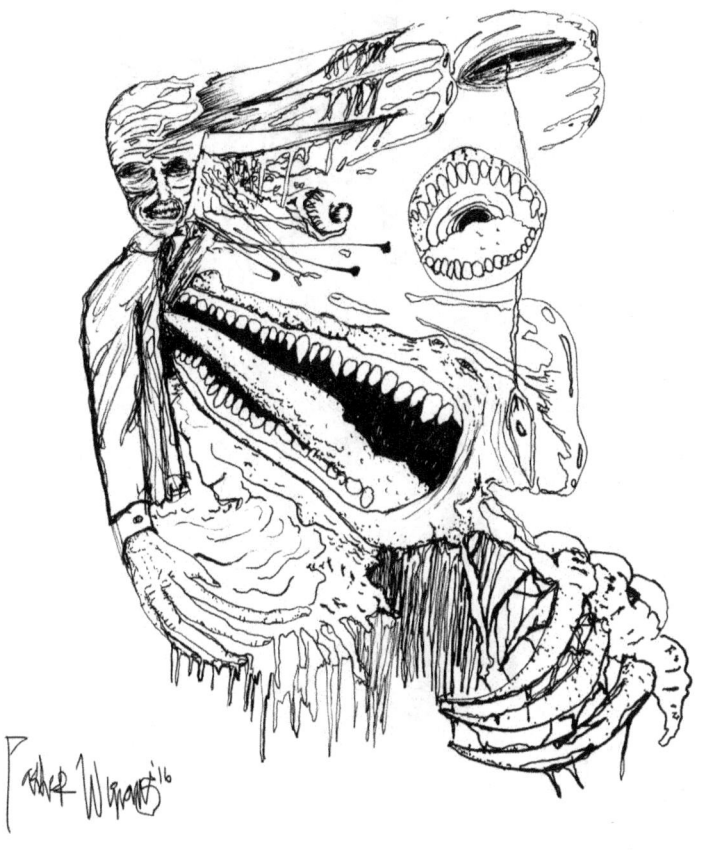

Out of Body

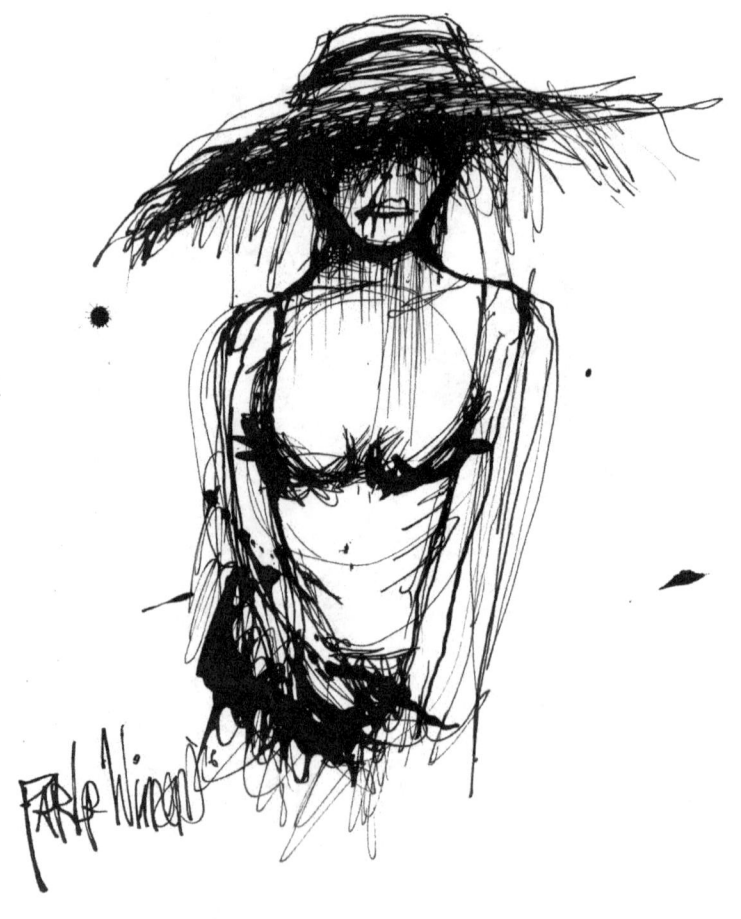

Beach Girl

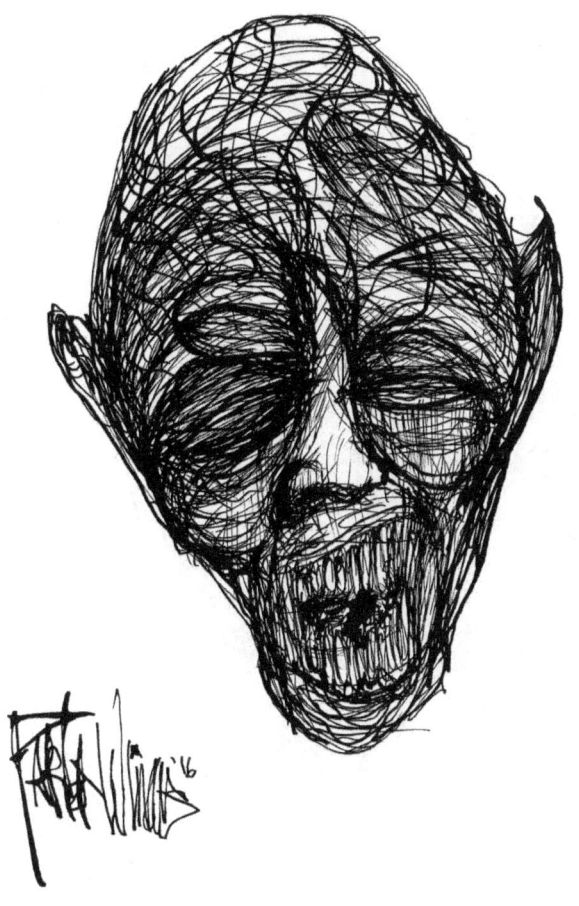

Laughter

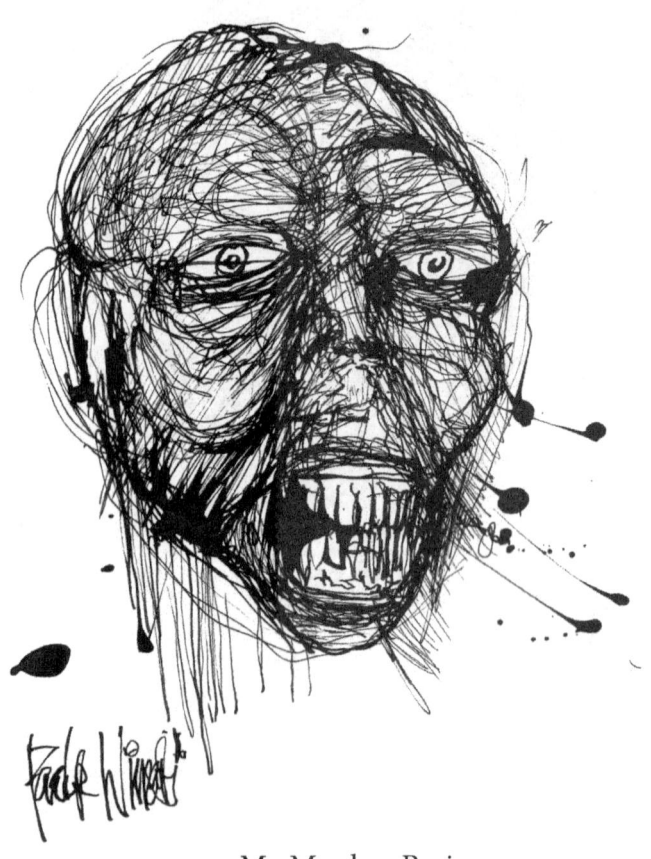

My Monkey Brain

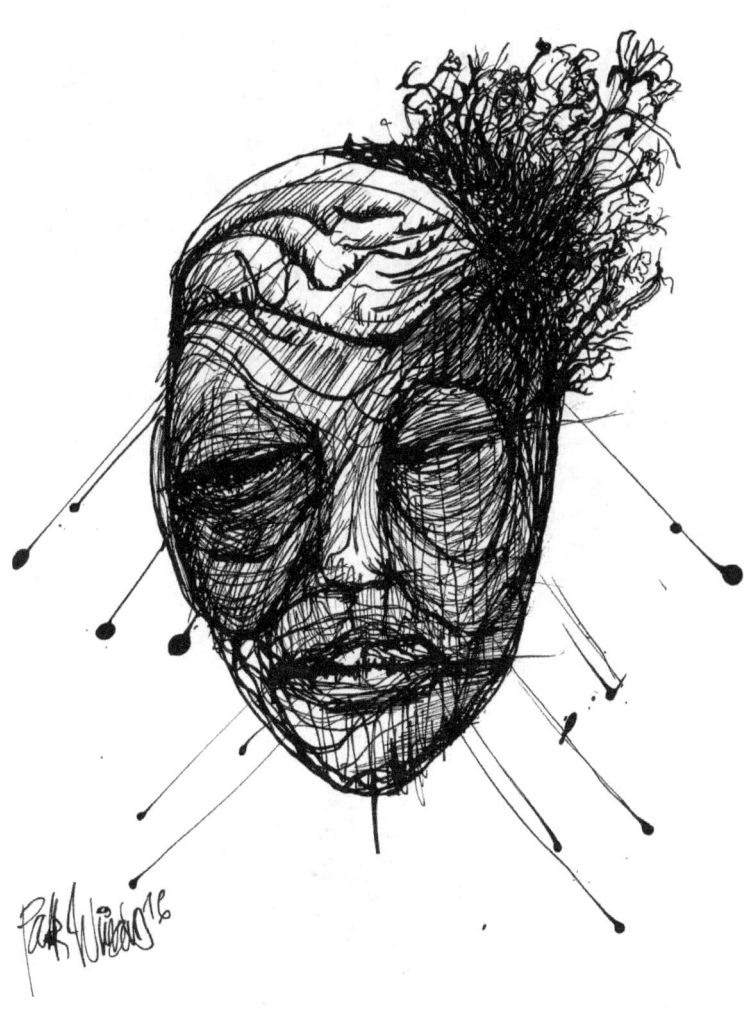

My Vegetable Brain

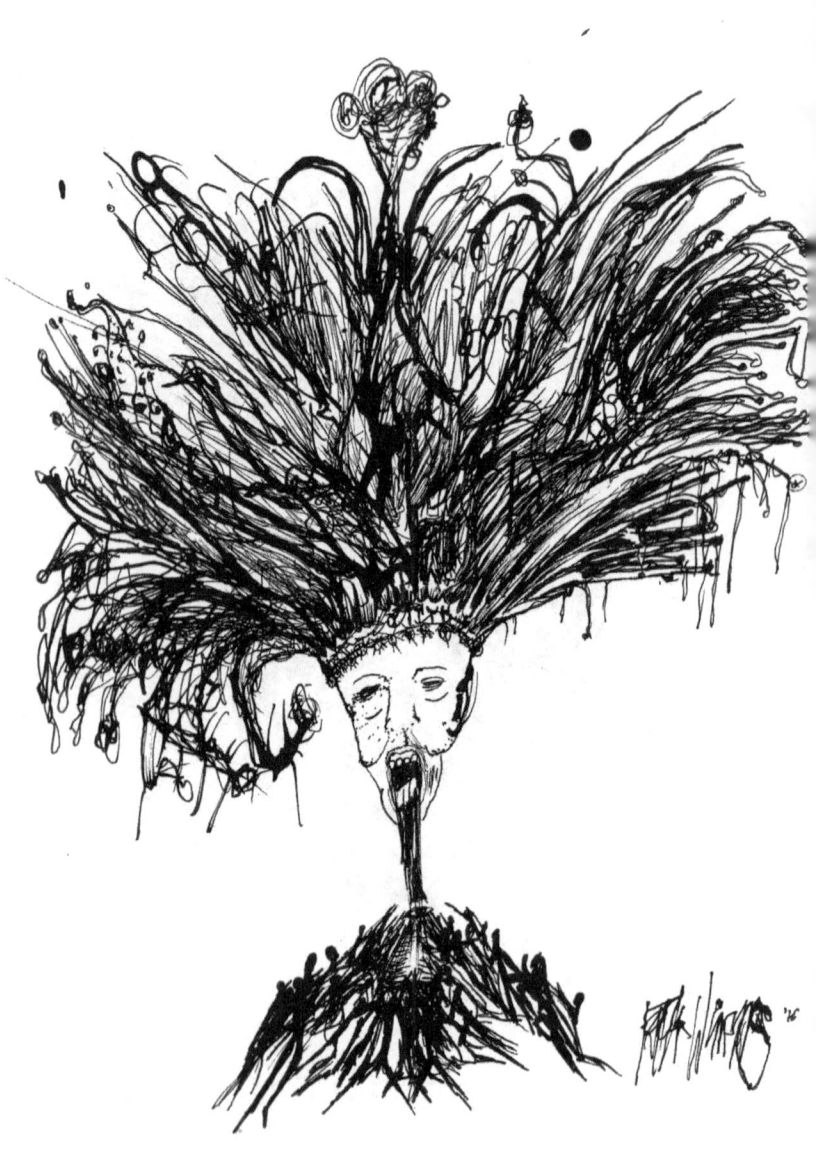

New King

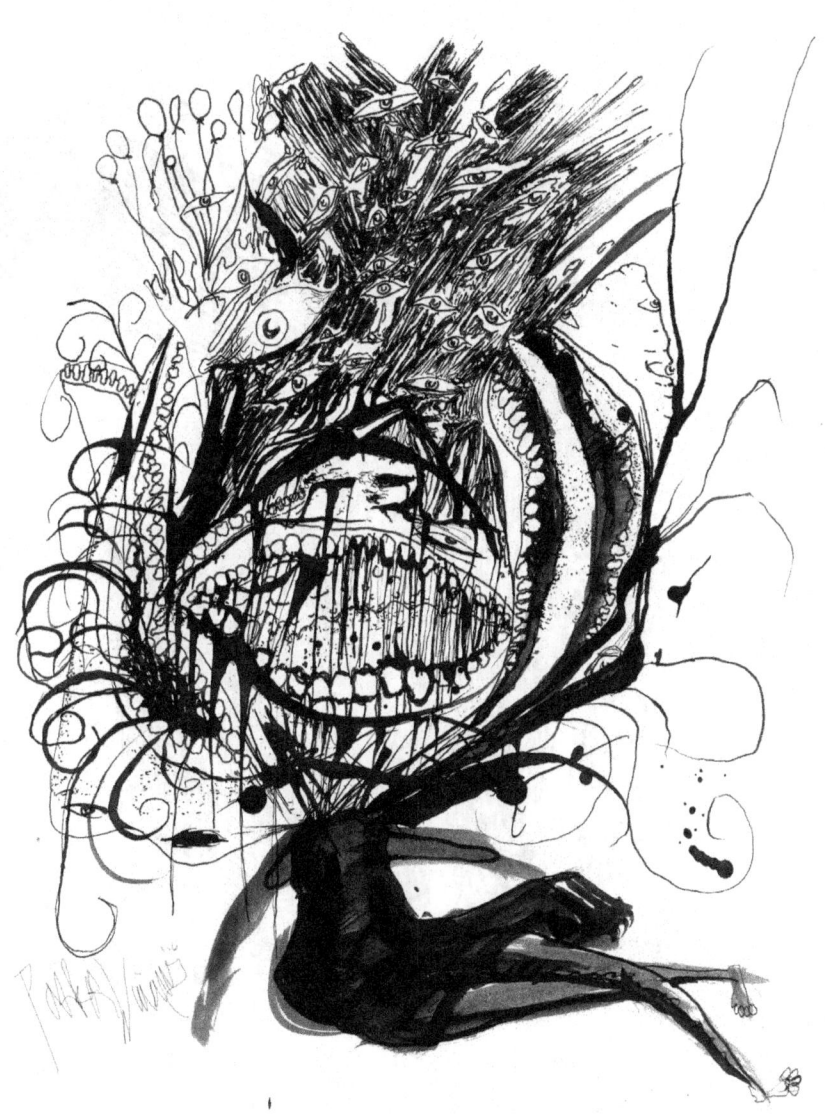

Party People

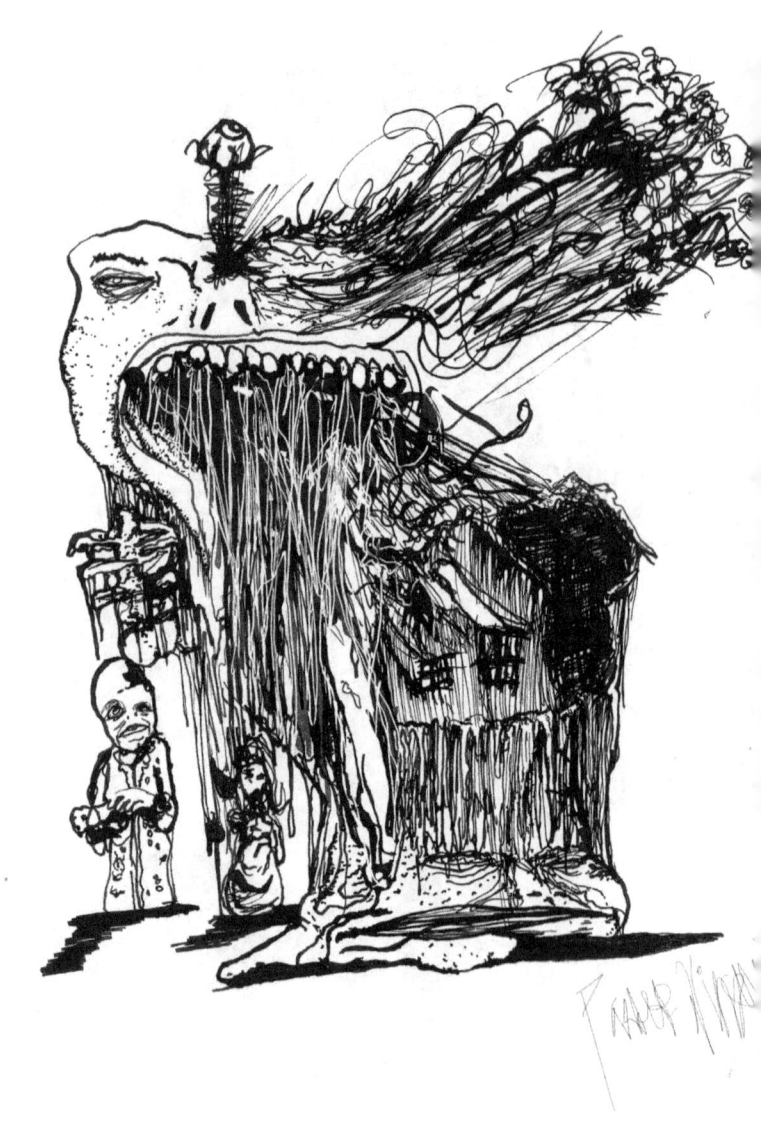

Disaster

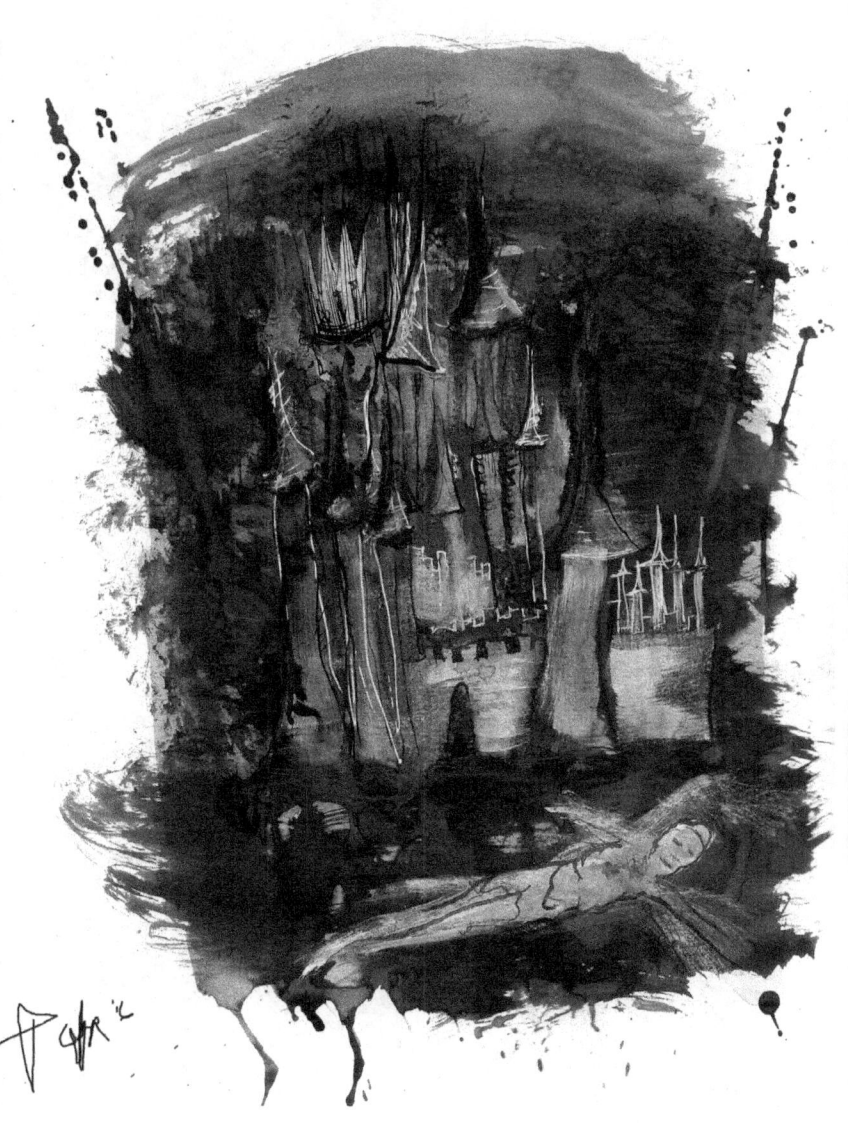

Nationalism: It's all about you

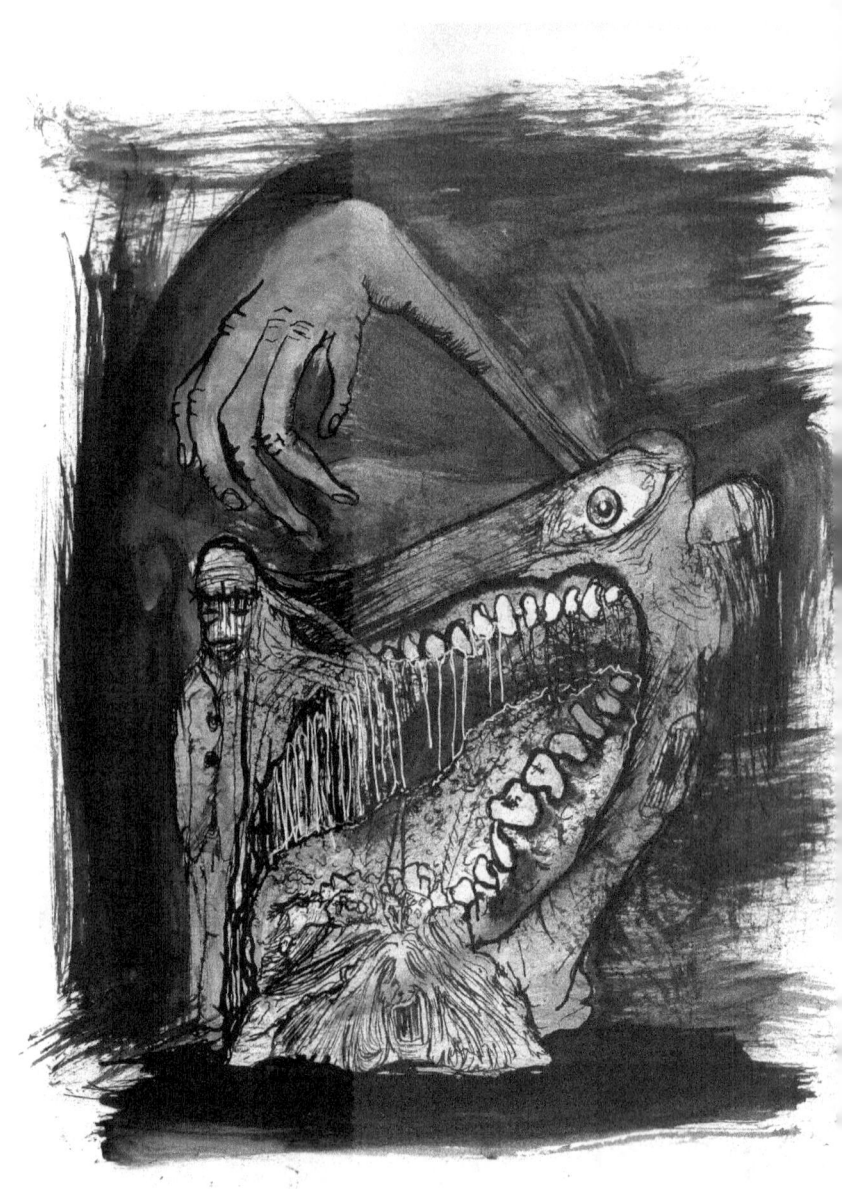

Temptation

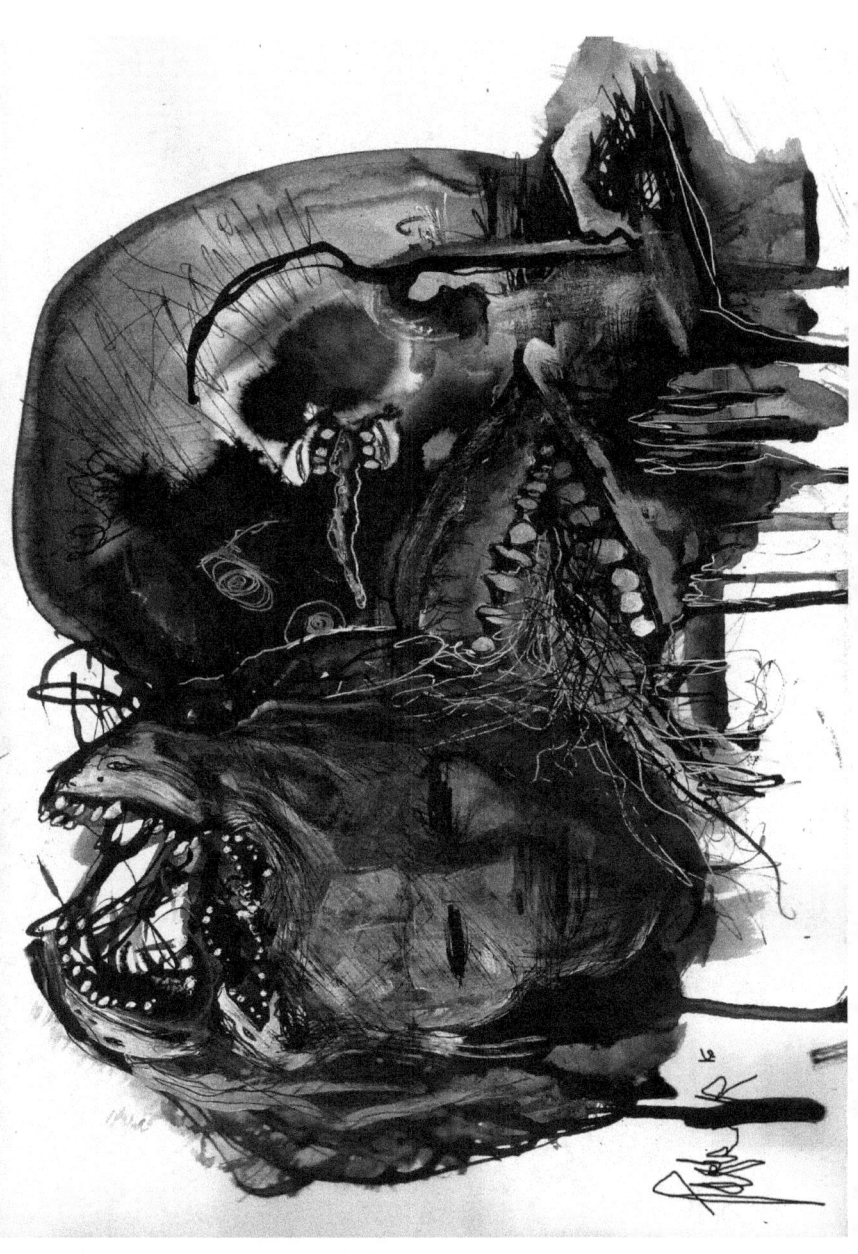

Professional Celebrity: Illustration from Easter Bunnies and Swastikas (EBS)

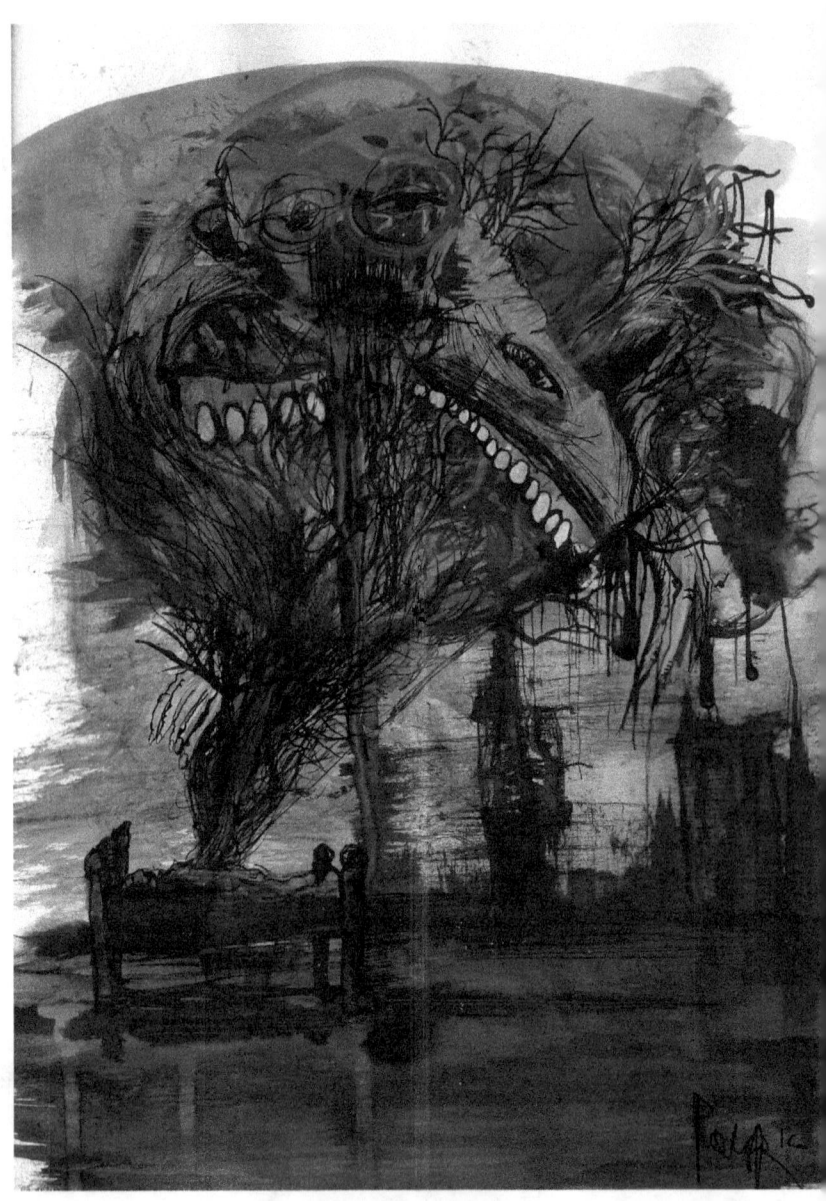

Bed: Illustration from EBS

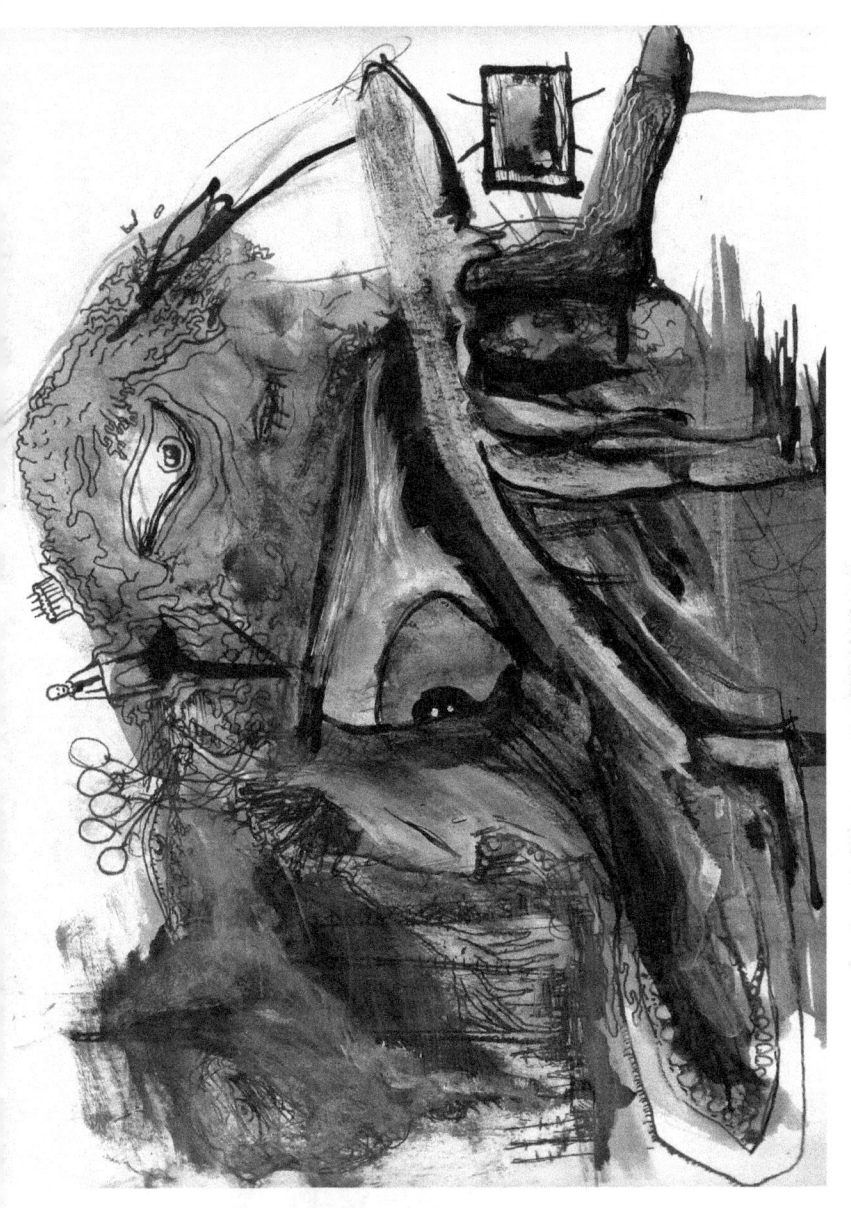

TV is Garbage: Illustration from EBS

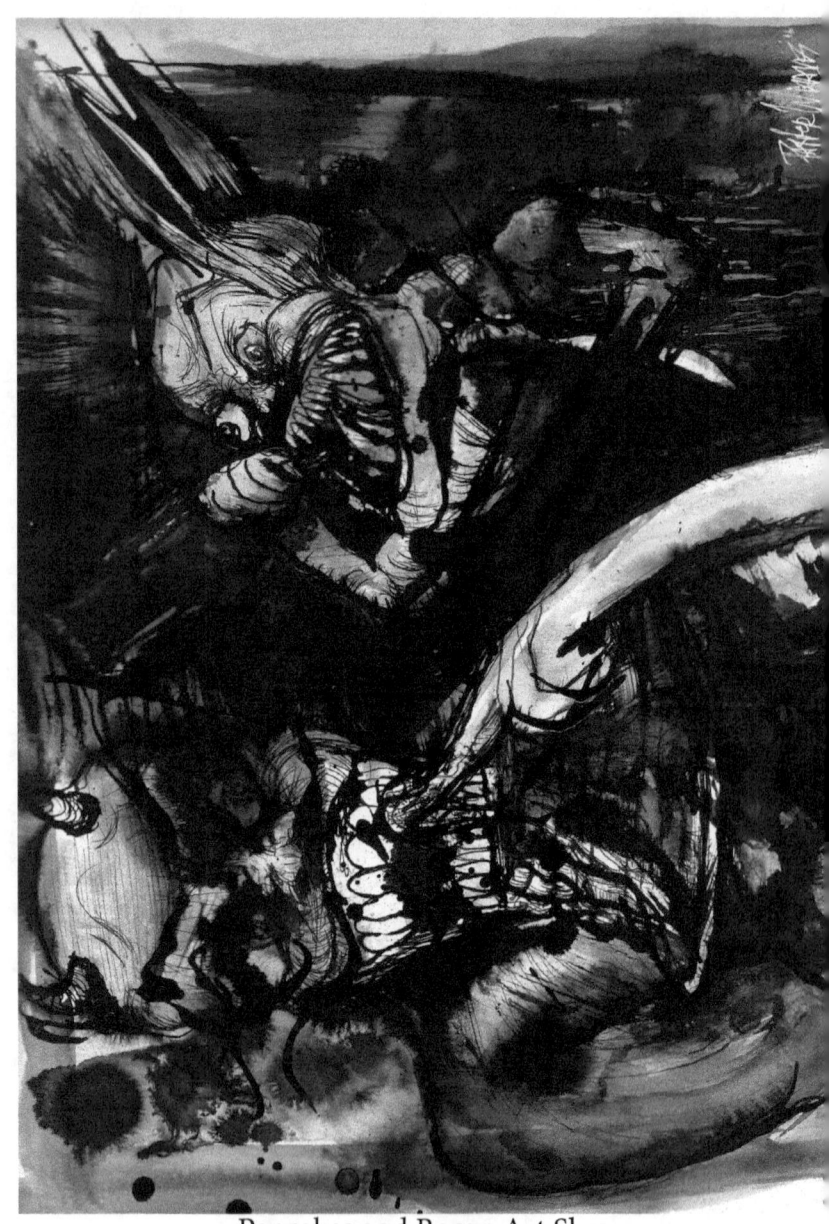

Pancakes and Booze Art Show

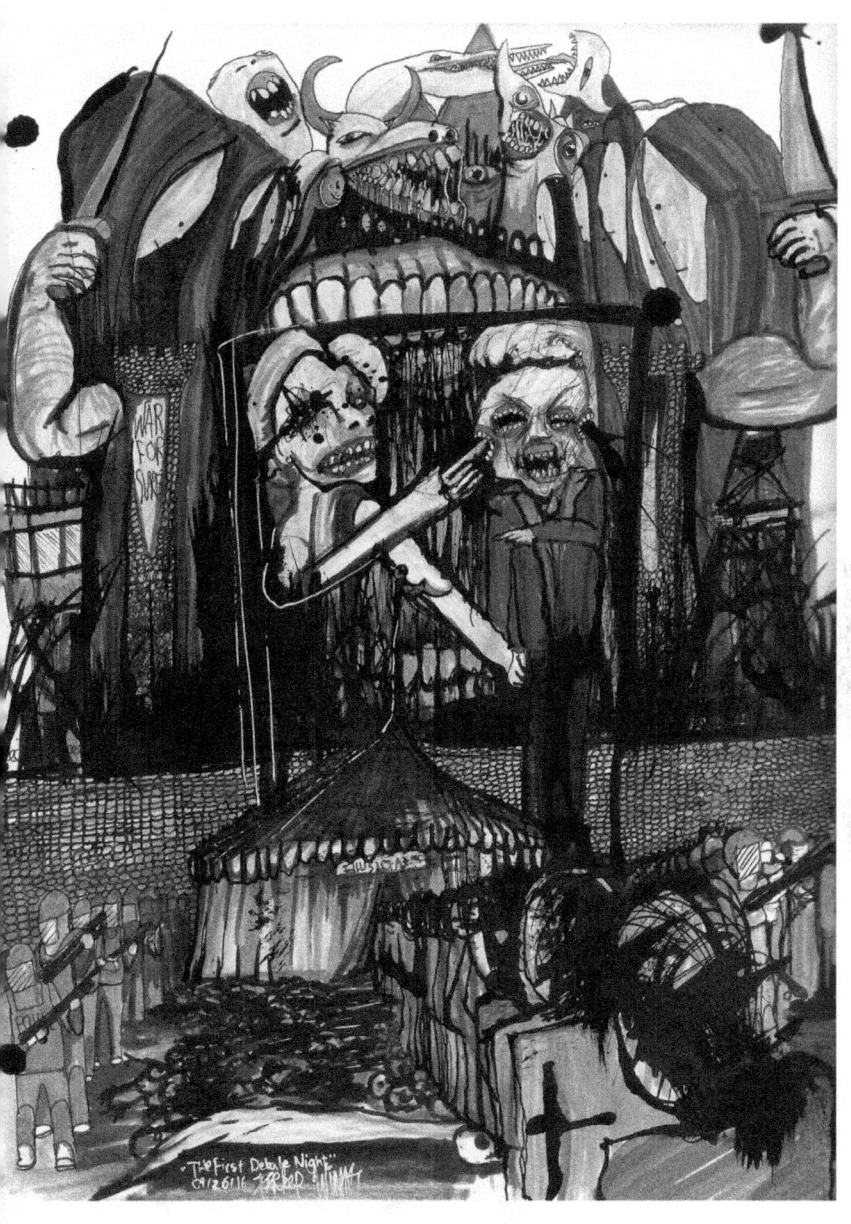

Debate: Reflection 6 from 2016 Election

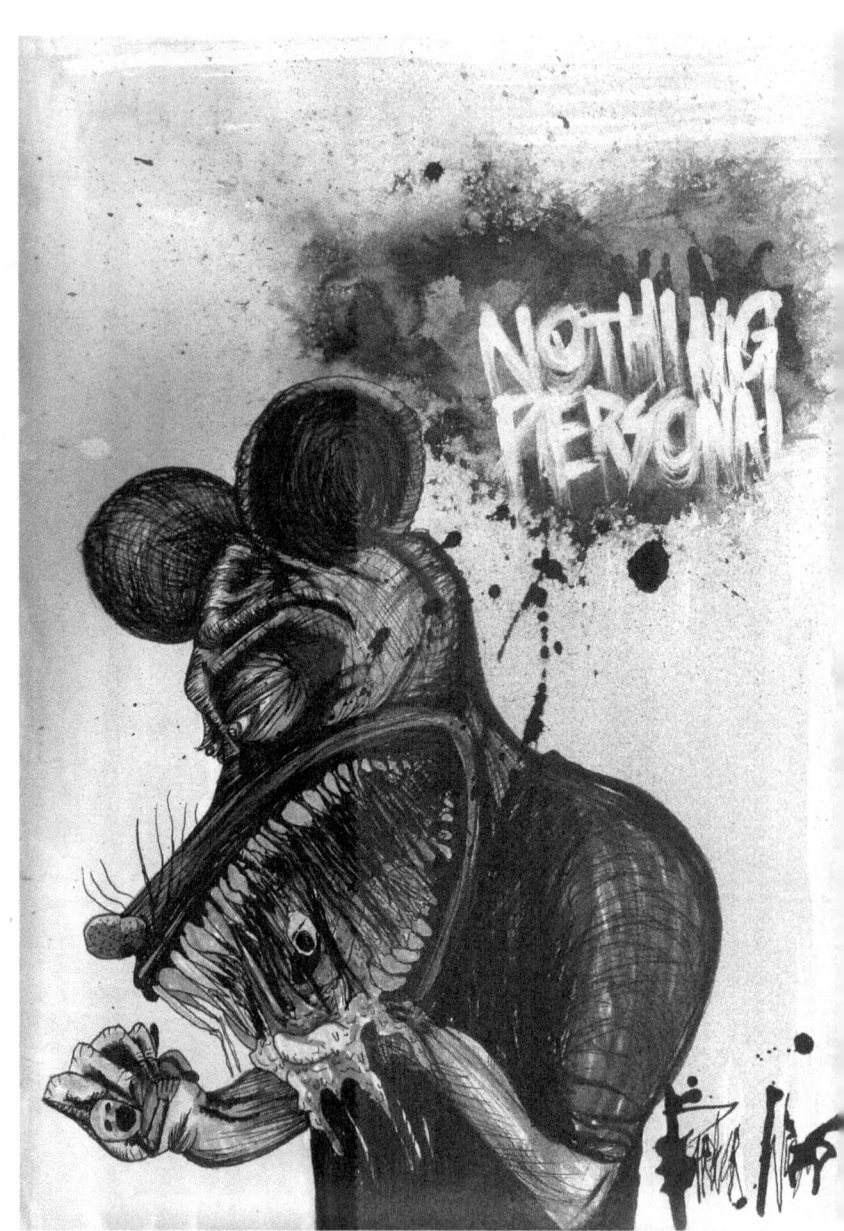

Propaganda

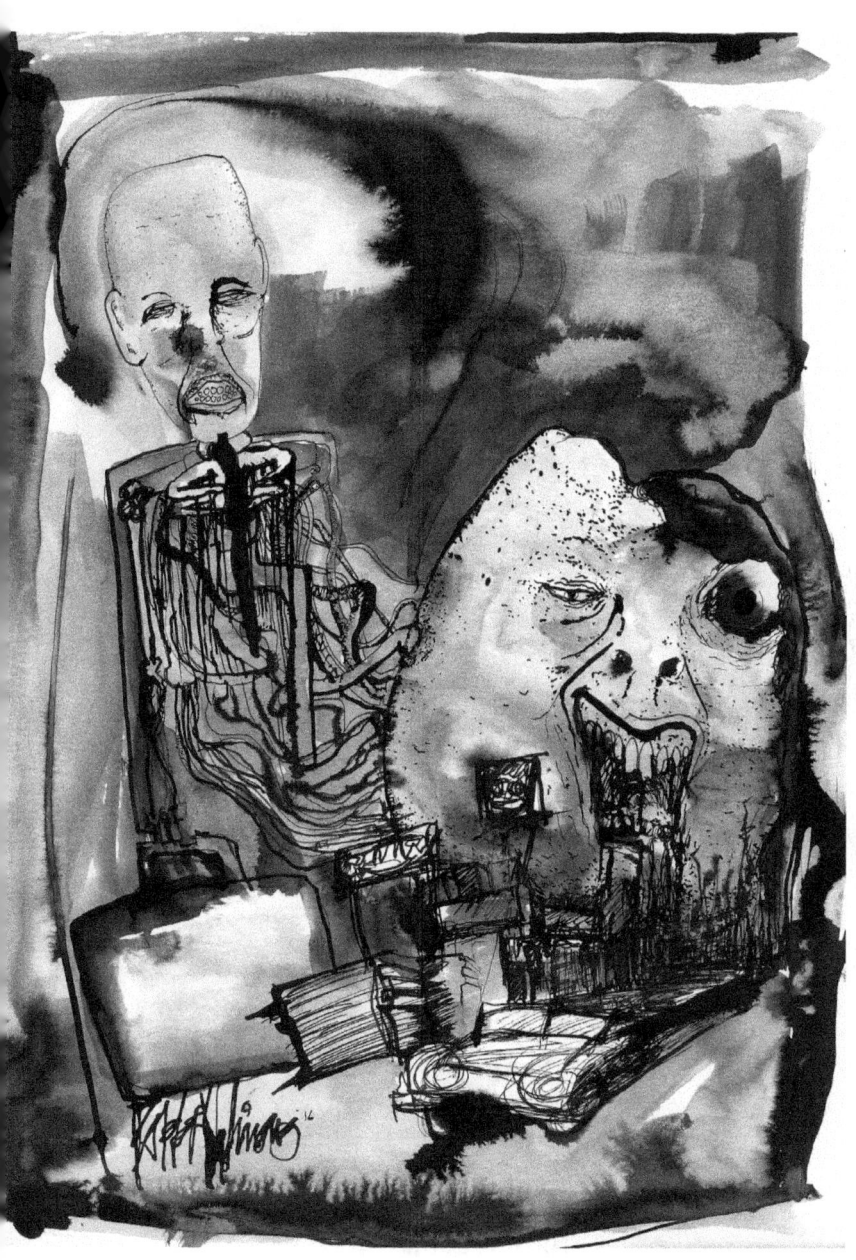

Main Street U.S.A.

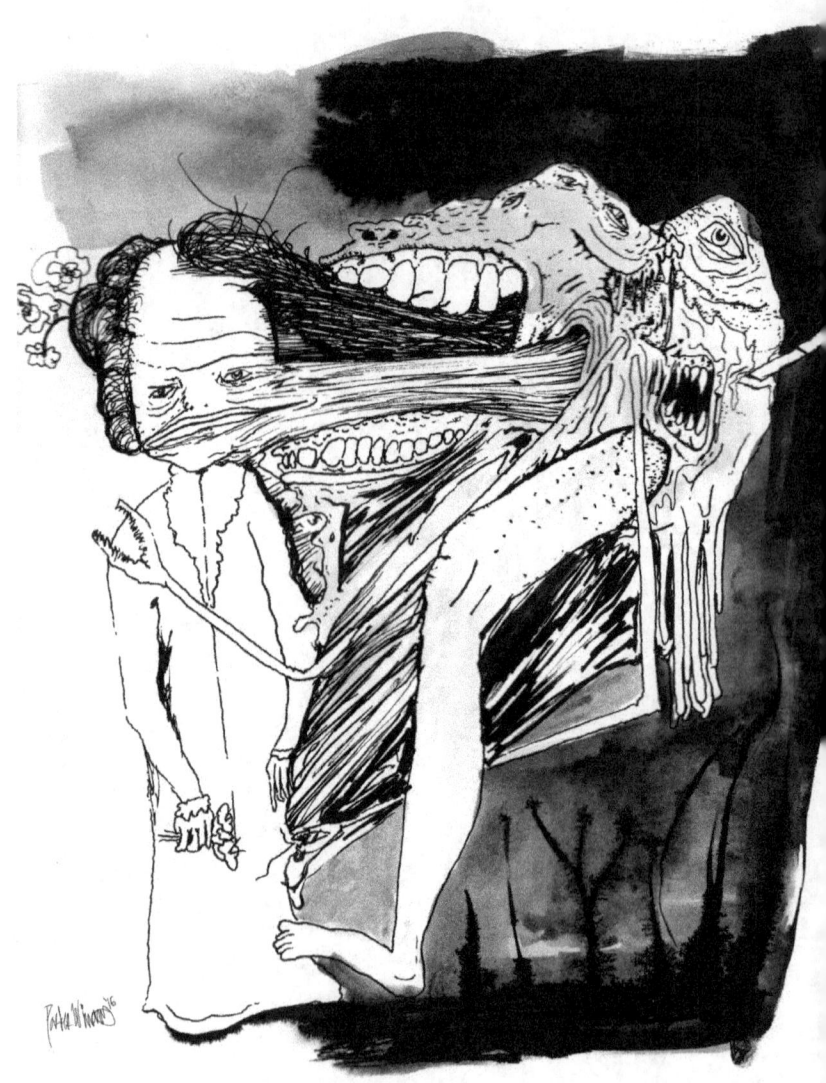

The Grandma

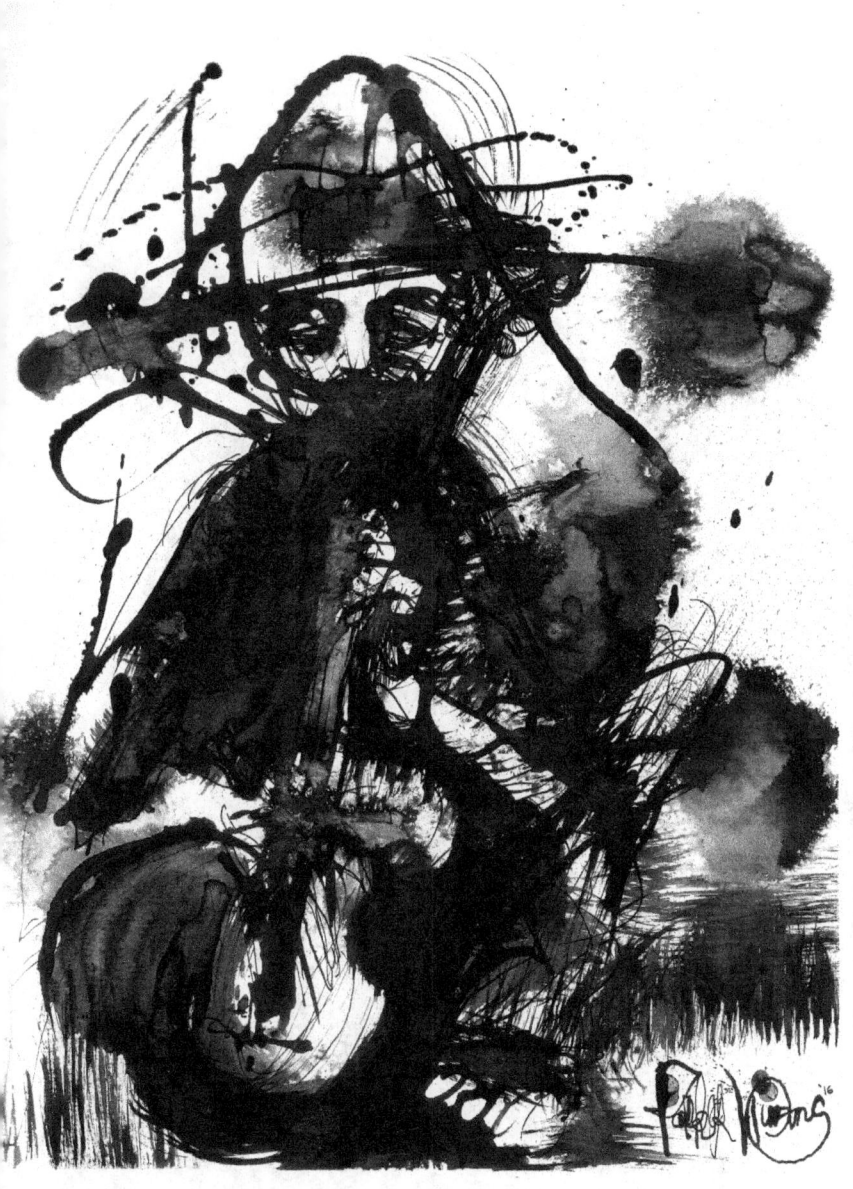

Man Playing Guitar

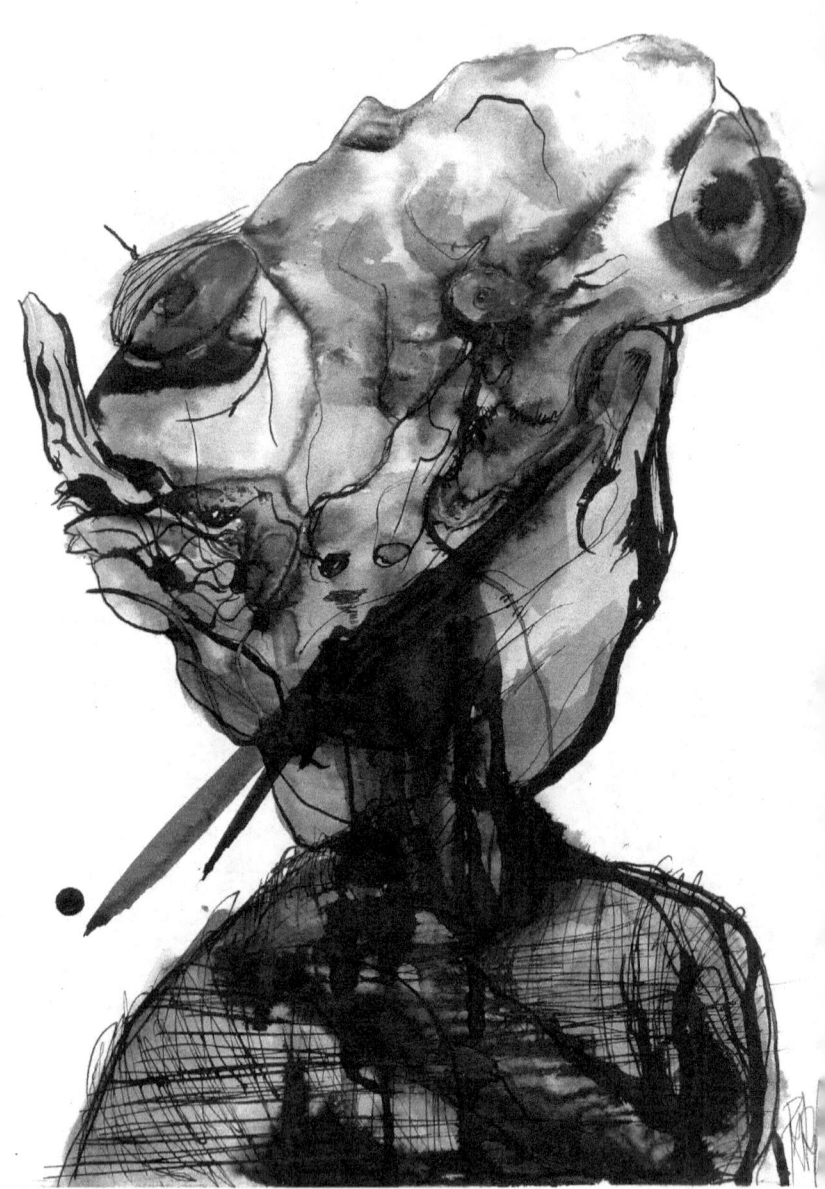
Morning Portrait

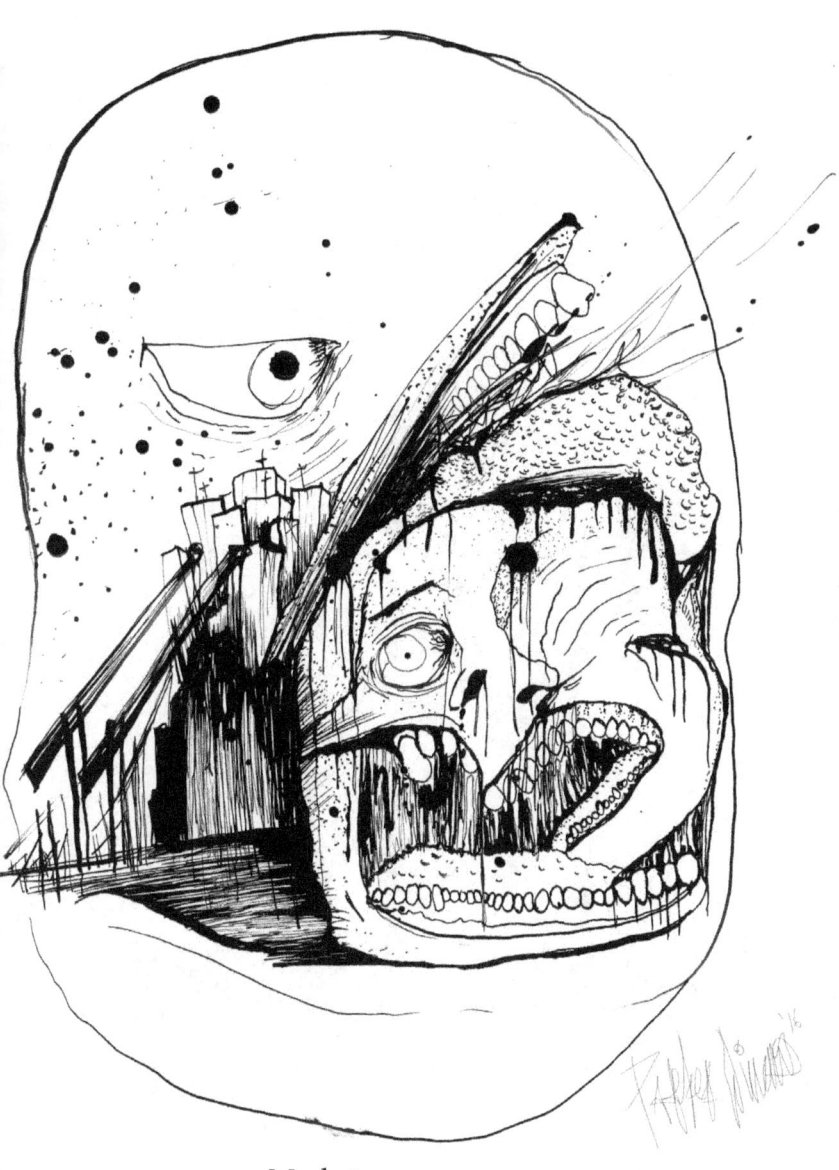

Markets

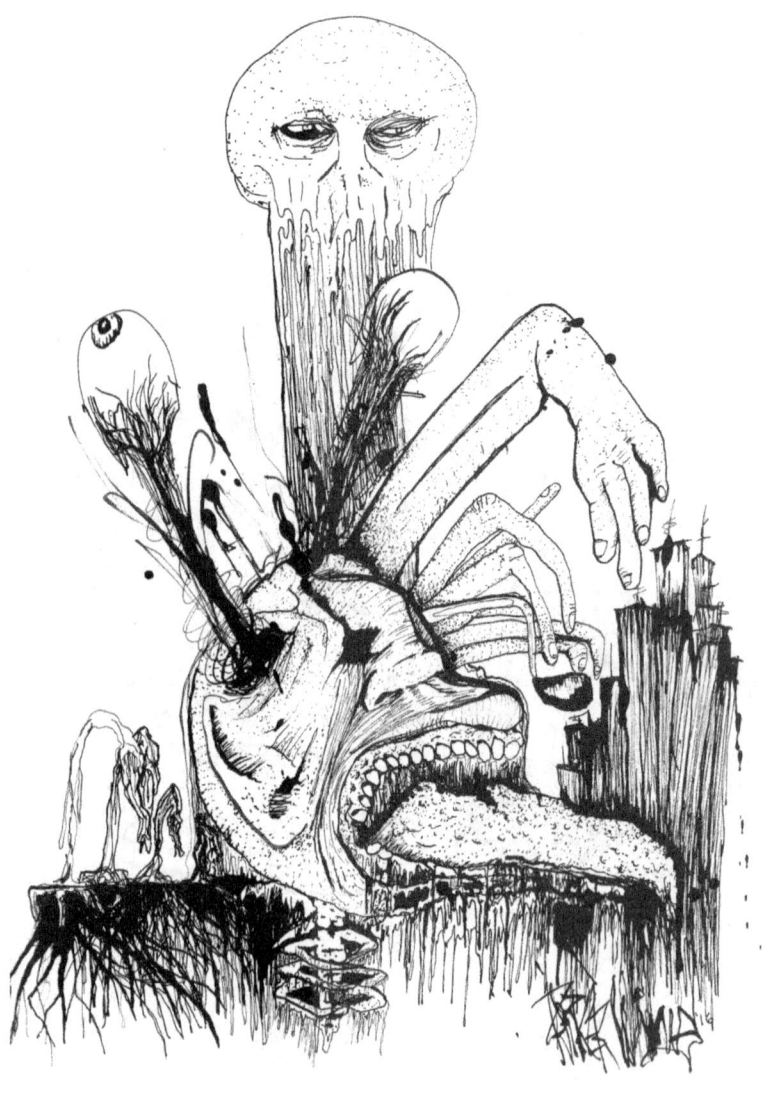

Under the Sun

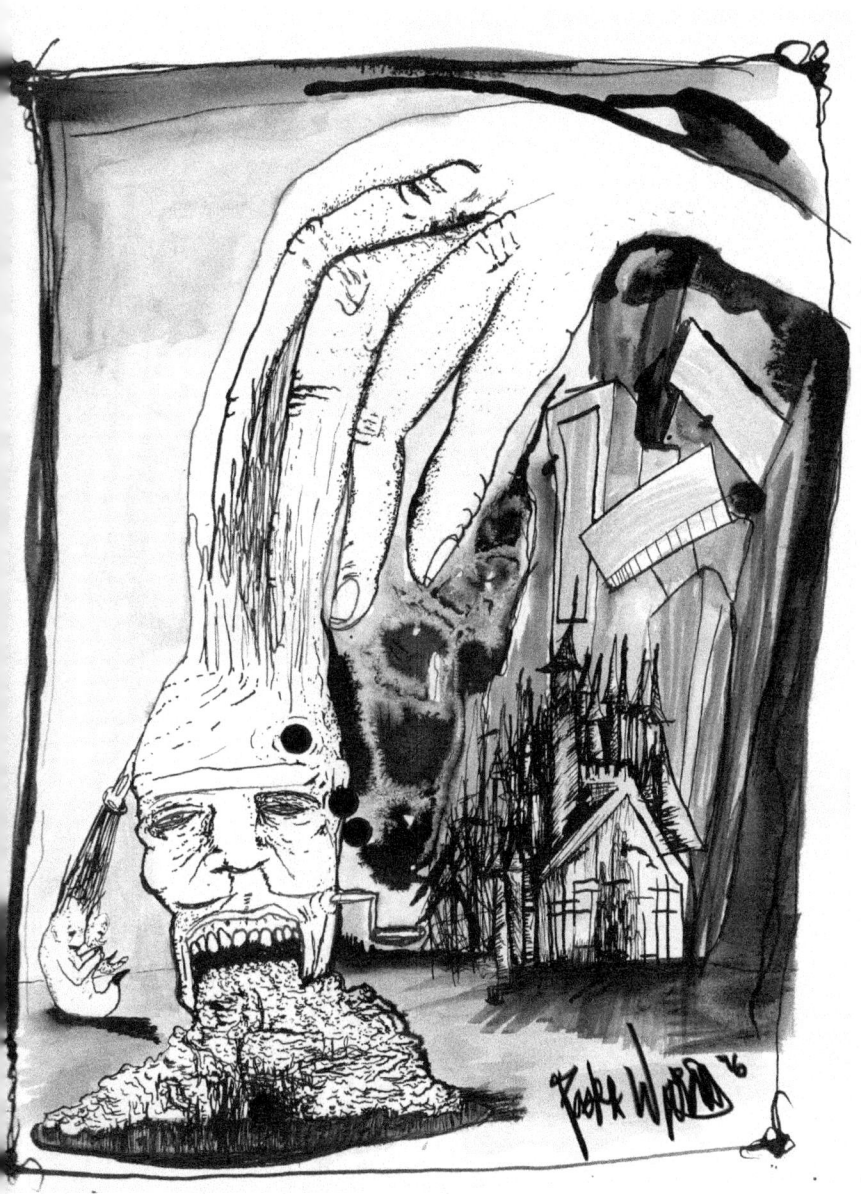

the Crank

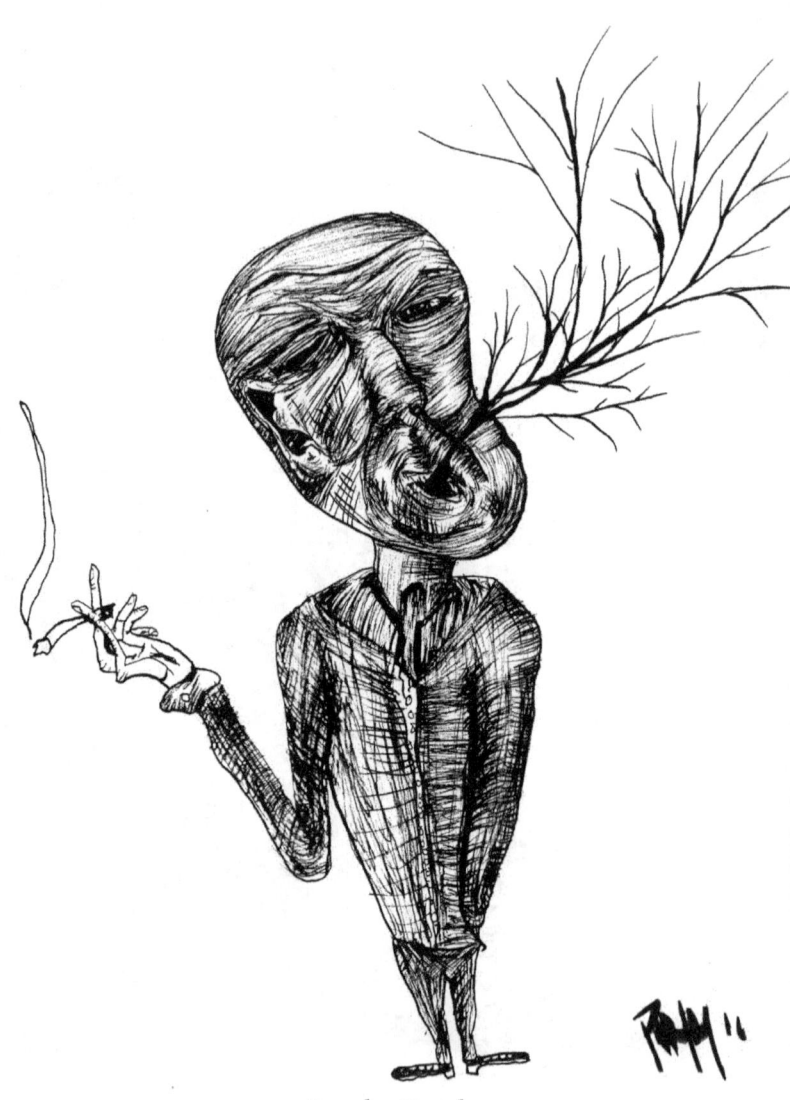

Smoke Break

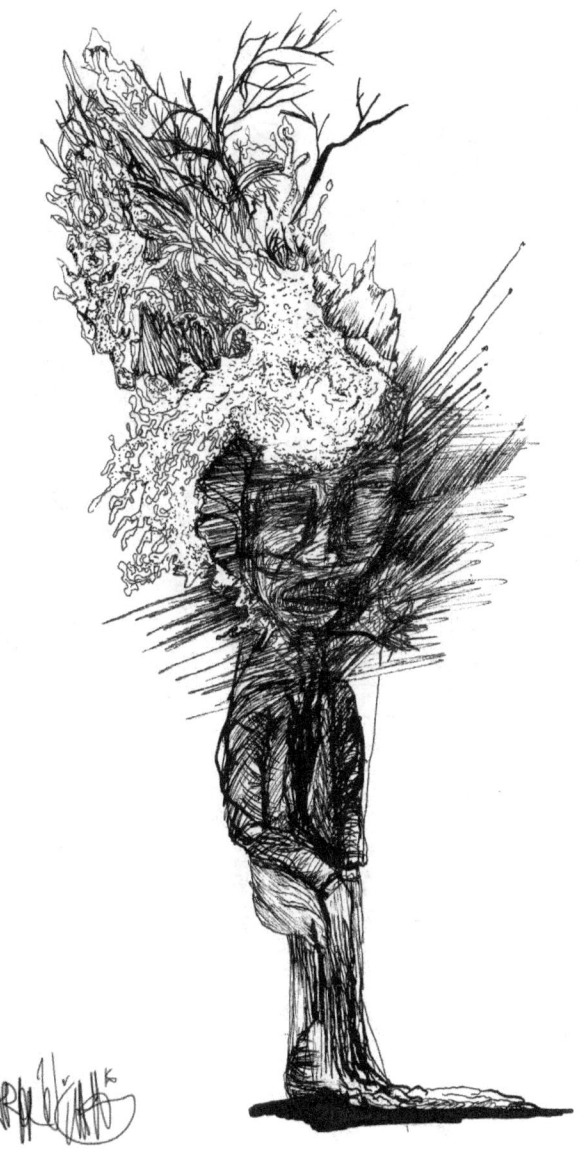

The Artist

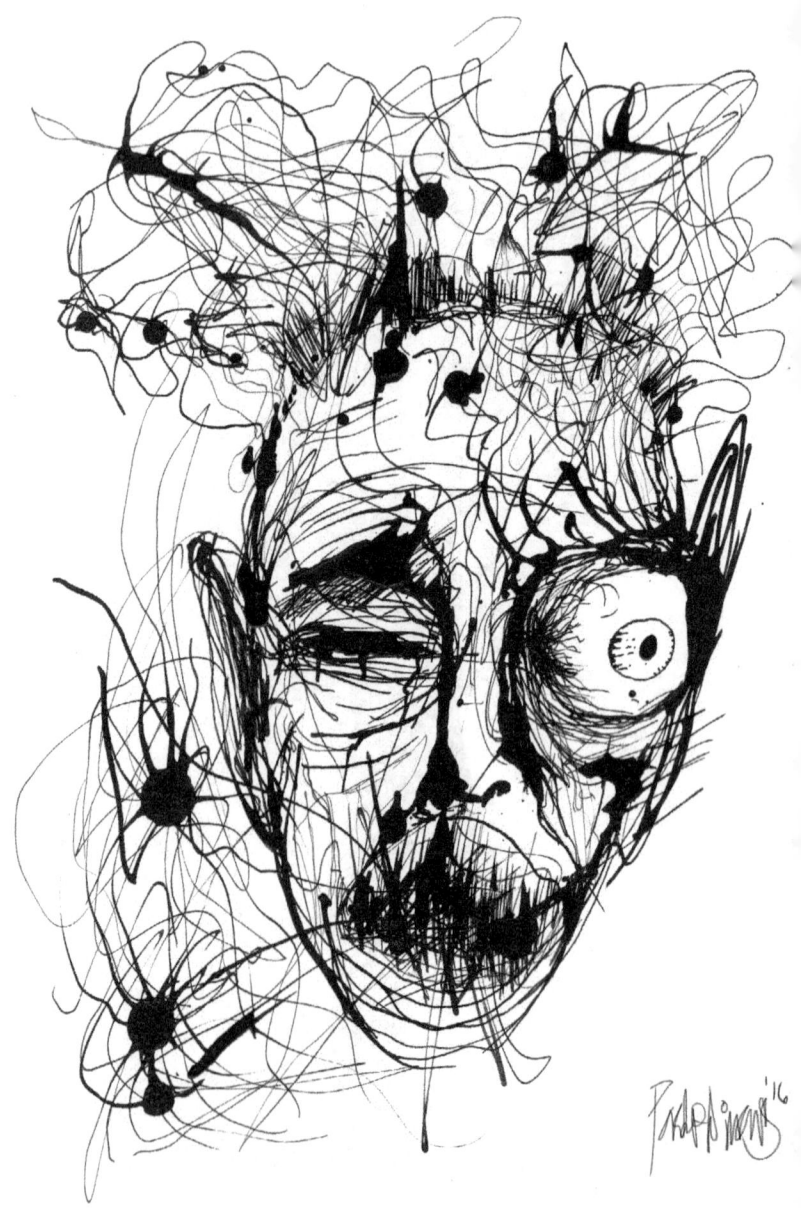

Ego Maniac

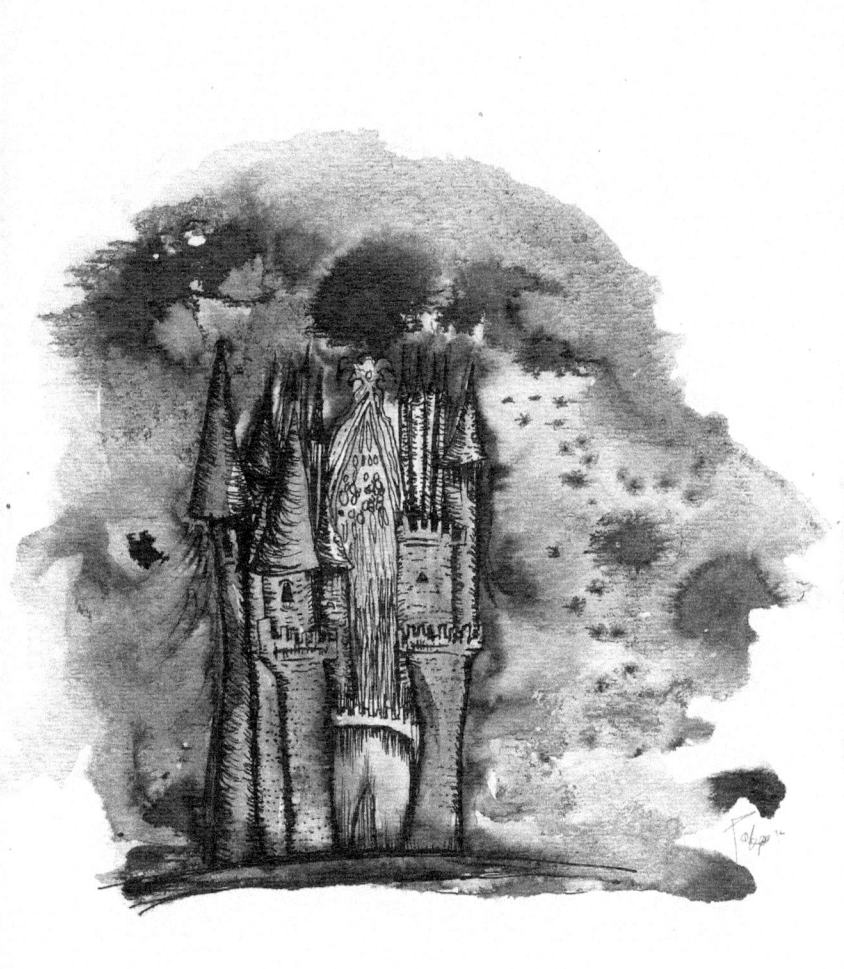

Kingdom

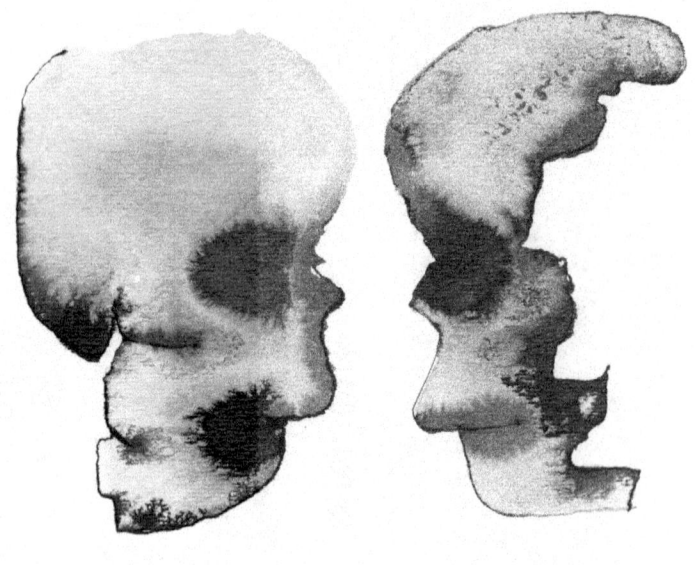

New Lovers

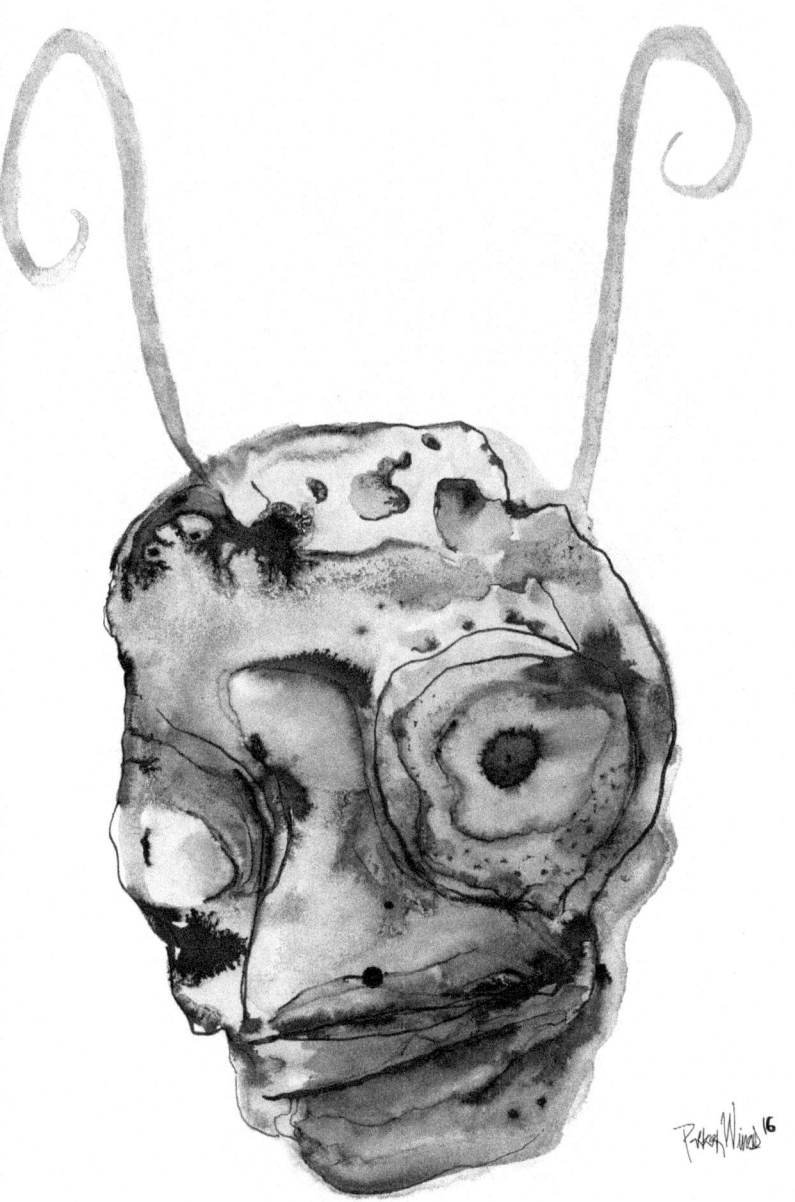

Insectoid

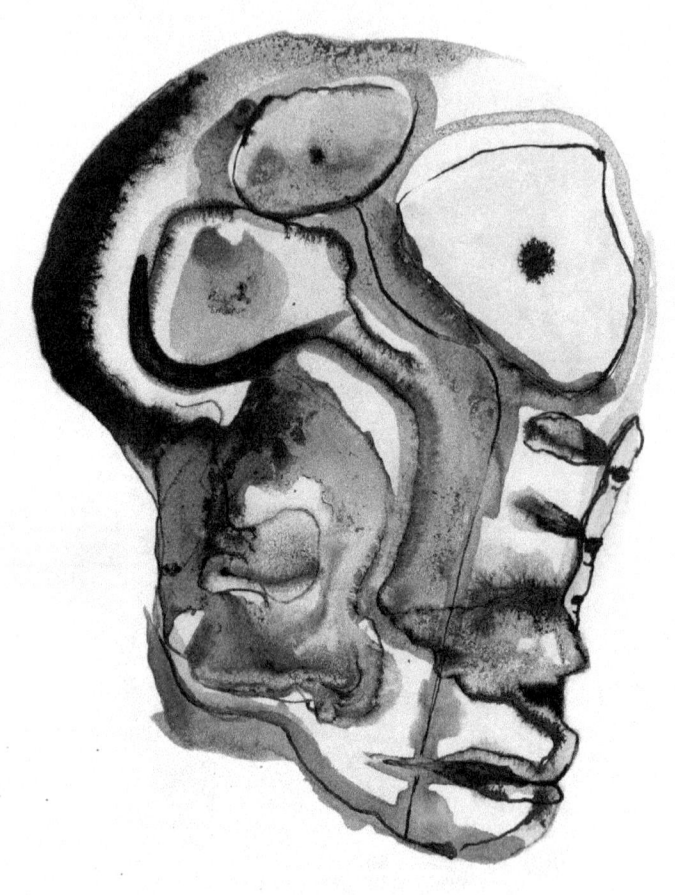

4 AM

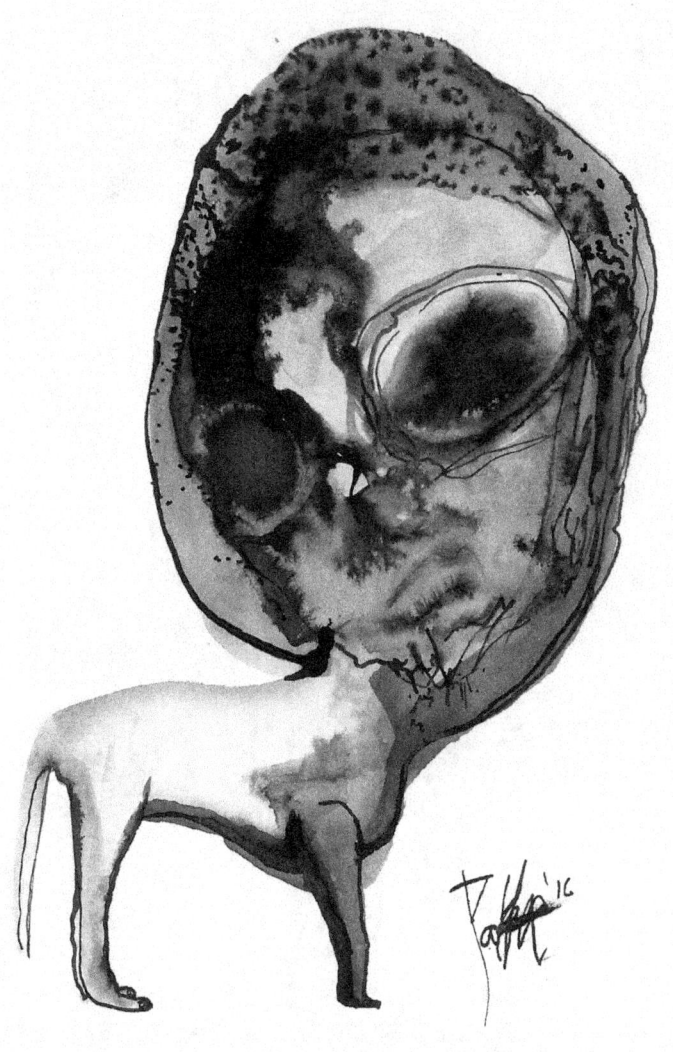

Beast

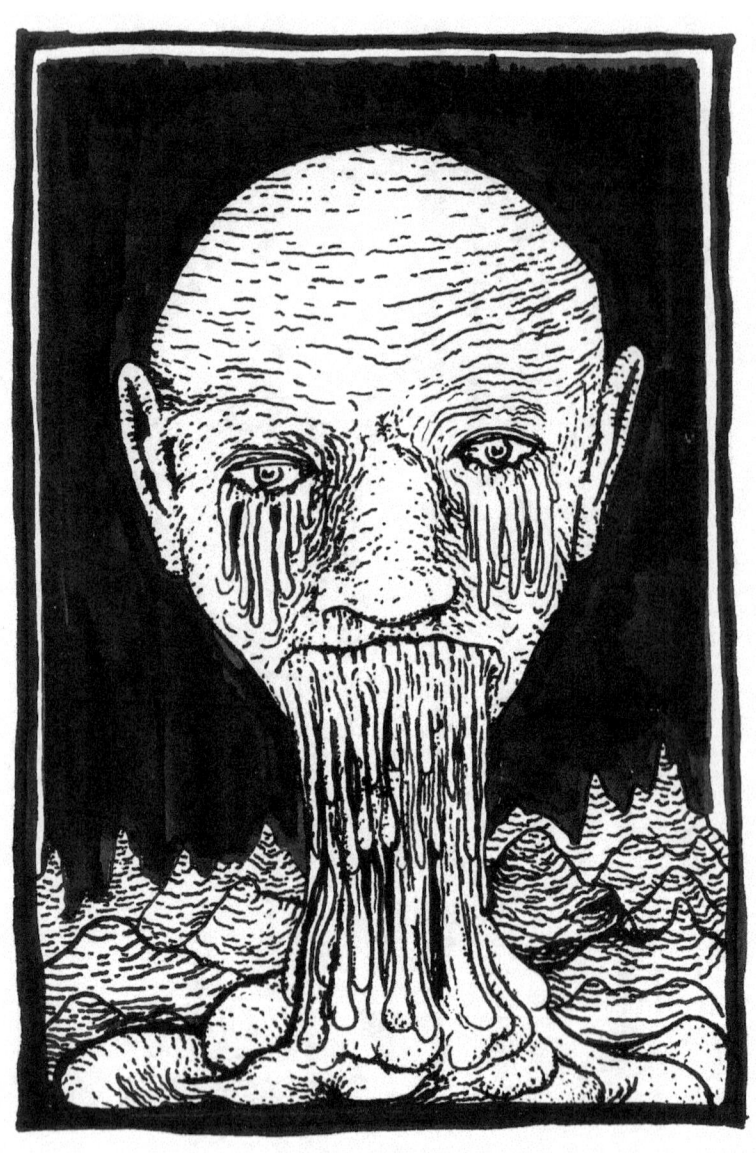

The one who makes the Mountains

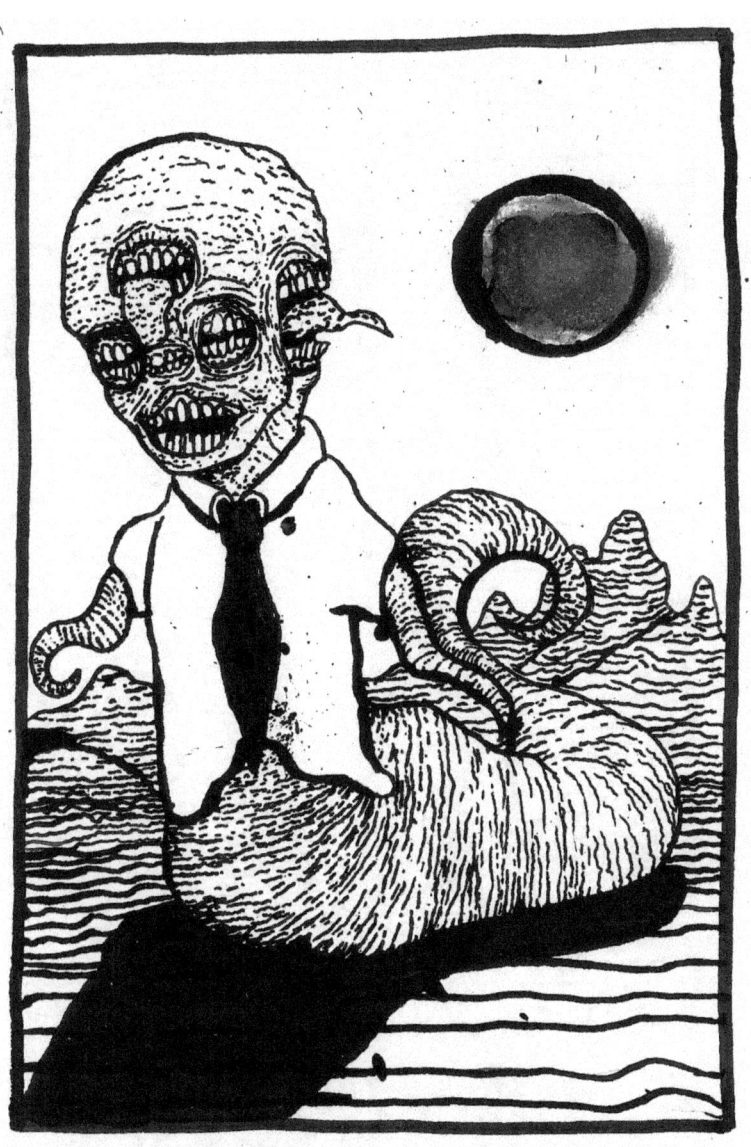

Your Boss

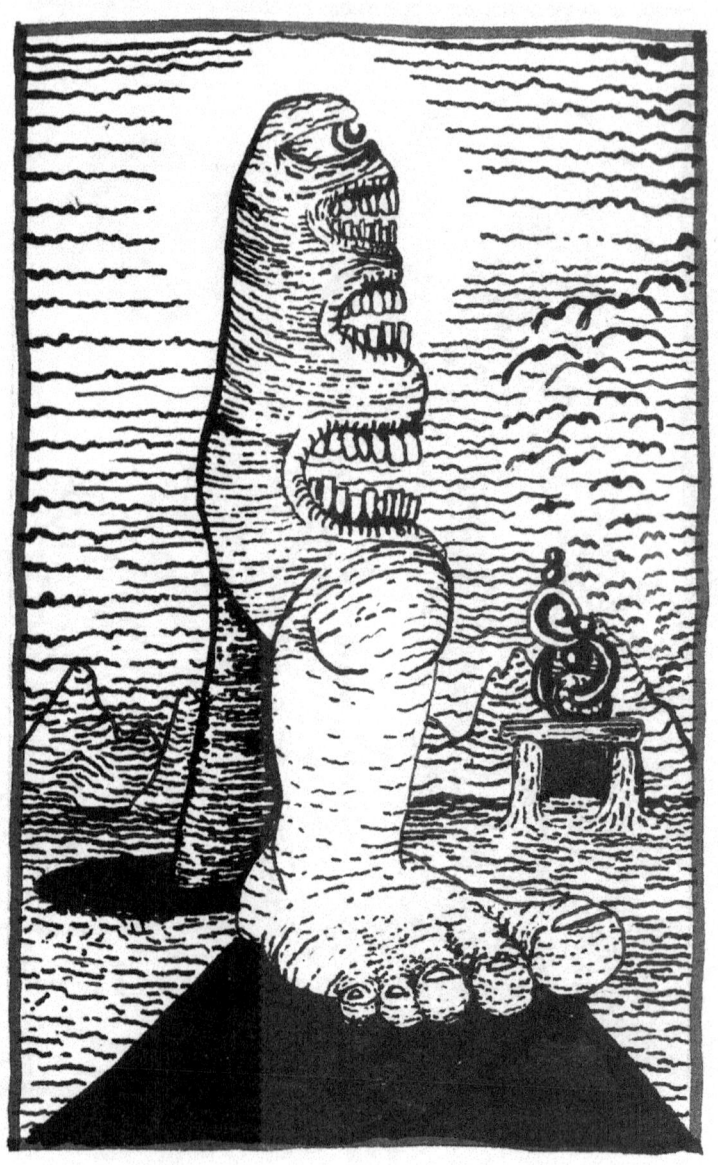

Monster in the Morning

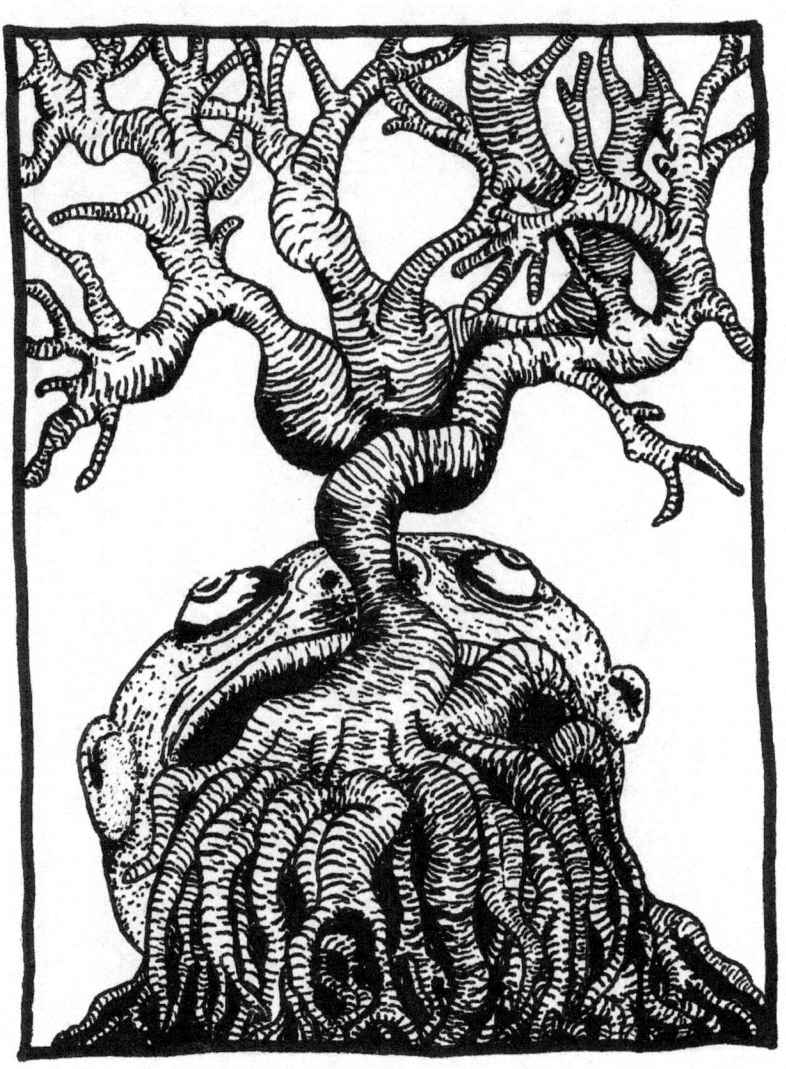

Roots

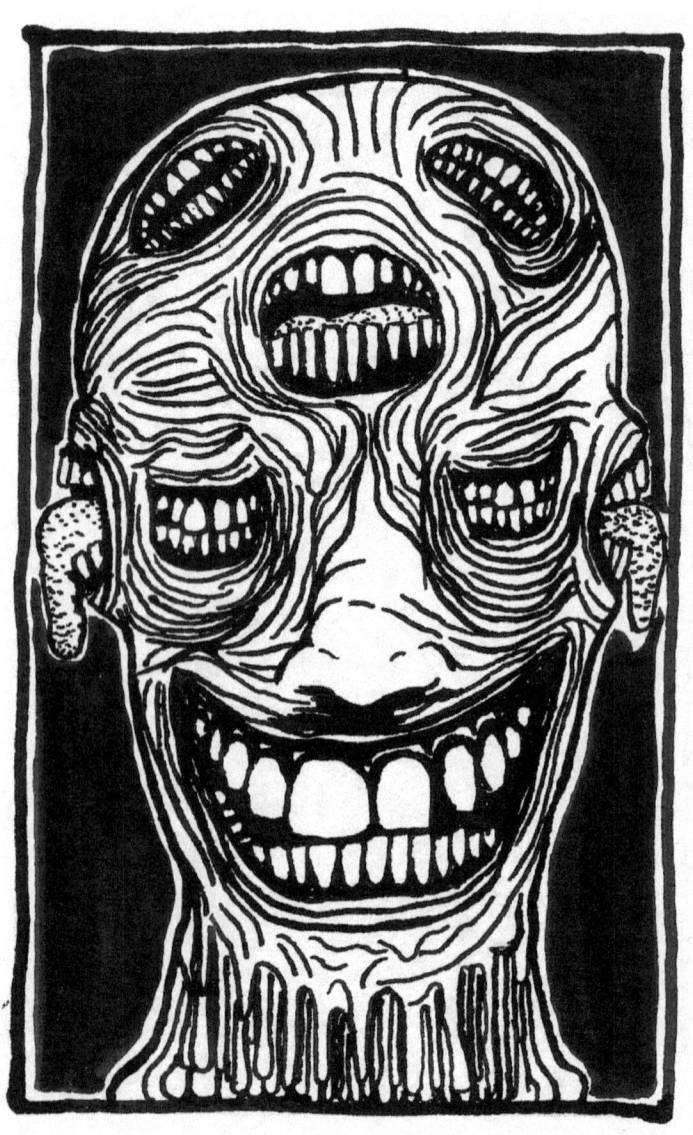

Feeding Time

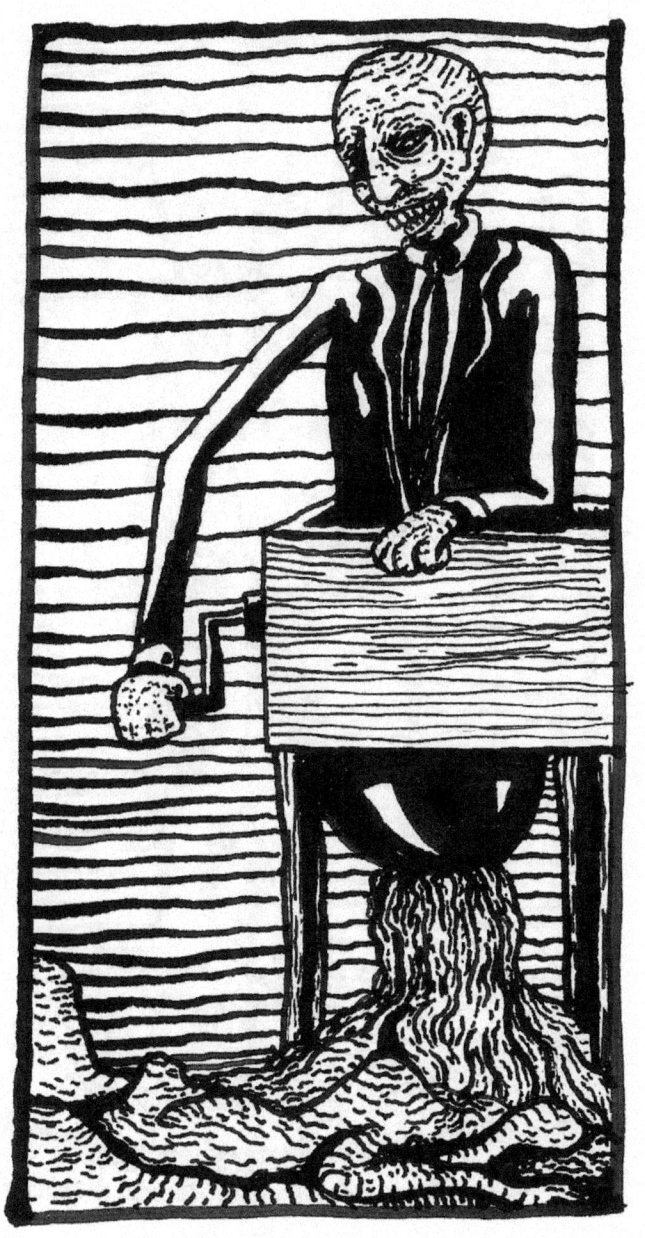

The Grinder

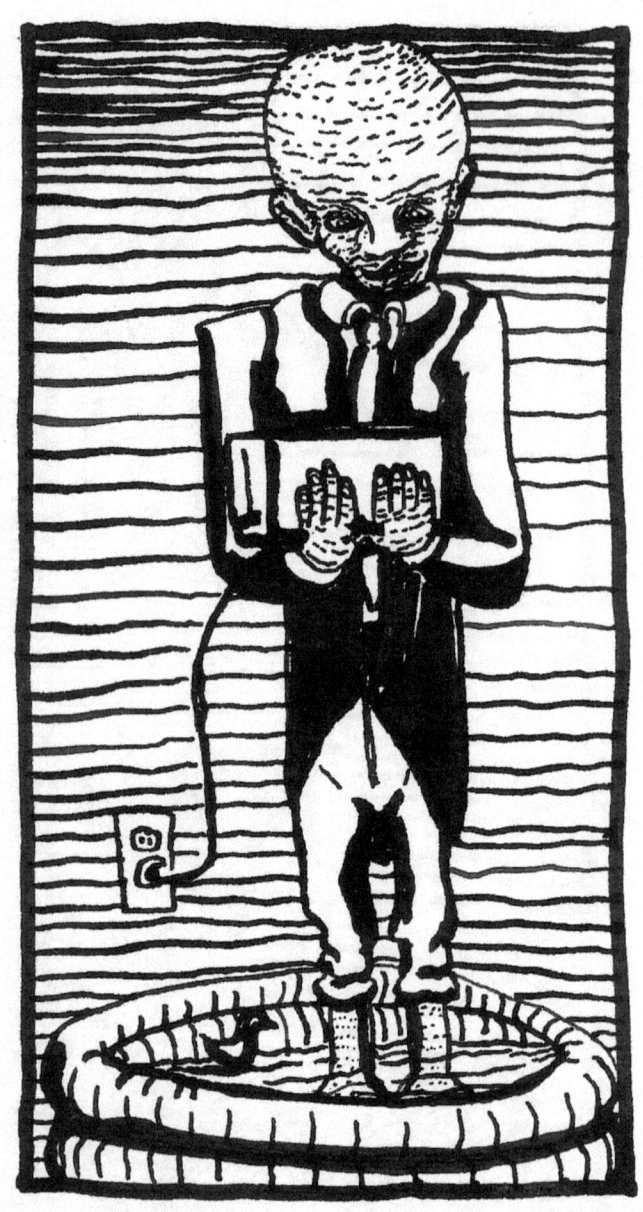

The Toaster

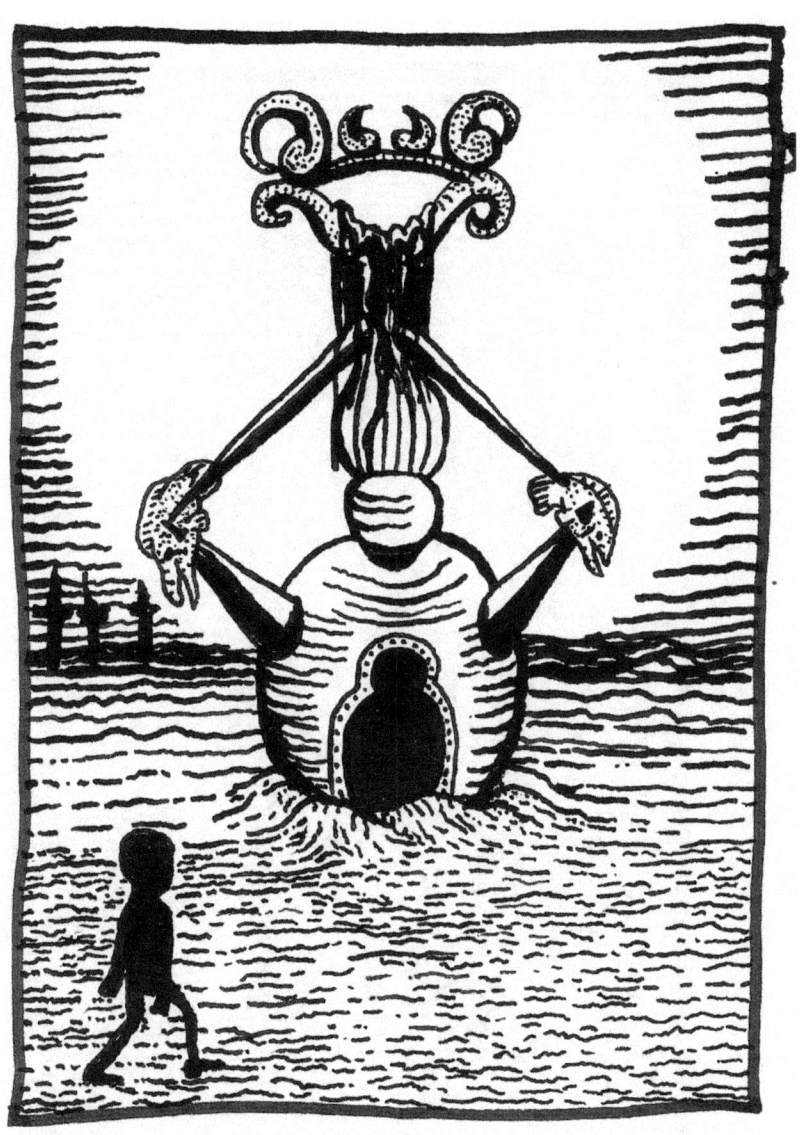

Home Again

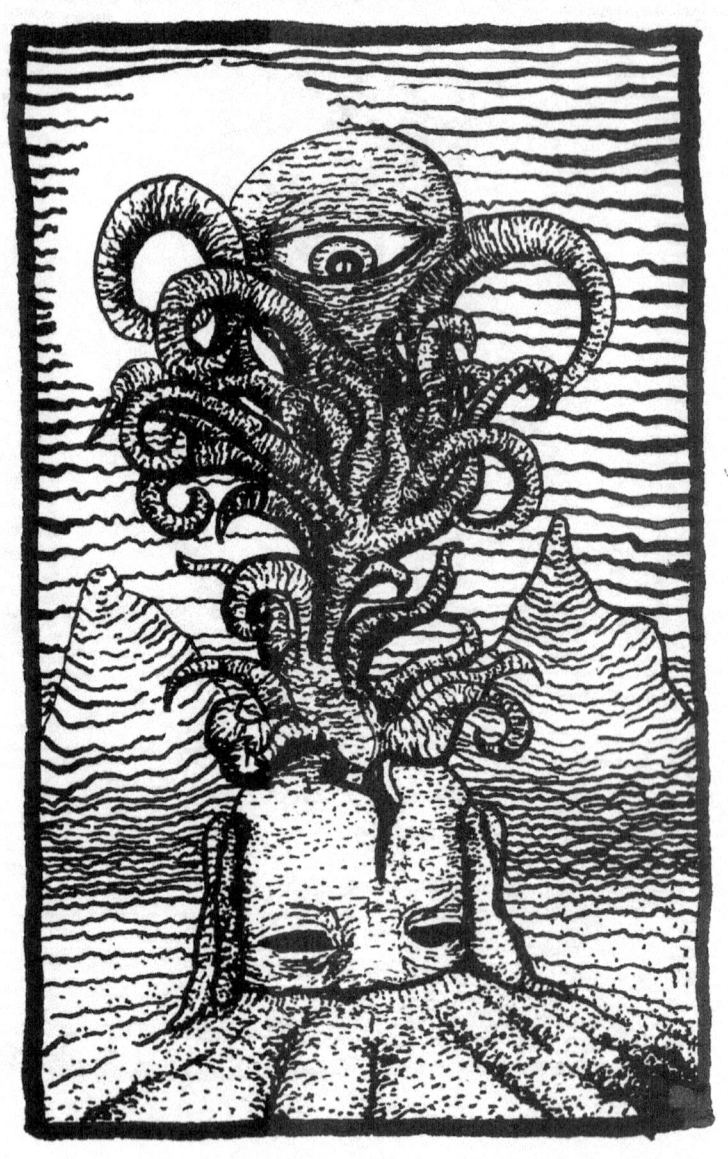

Meditation is Good

MESSAGE NOTES

SUNDAY MORNING SERVICE

~~Robert Bishop~~ *:: Senior Pastor*

APRIL 10, 2016

PARKER WINANS IS AN AMERICAN ARTIST. HE WAS RAISED IN MINDEN, NEVADA AND LOS ANGELES. HE WANTED TO WRITE THIS PART IN THE FIRST PERSON BECAUSE HE WAS TOLD THAT IT WOULD LOOK ~~UP~~ UNPROFFESSIONAL. HE CURRENTLY LIVES IN LOS ANGELES.

TO LEARN MORE, FOLLOW ON SOCIAL, SEND HAIKUS, BUY ART, ETC. GO TO WWW.PARKERWINANS.COM

© COPYRIGHT 2017 PARKER WINANS

www.ingramcontent.com/pod-product-compliance
Lightning Source LLC
Chambersburg PA
CBHW061442180526
45170CB00004B/1523